FLORALS BY HAND

HOW TO DRAW AND DESIGN MODERN FLORAL PROJECTS

Alli Koch

Copyright © 2018 Alli Koch

Published by Paige Tate & Co.
Paige Tate & Co. is an imprint of Blue Star Press
PO Box 8835, Bend, OR 97708
contact@paigetate.com
www.paigetate.com

Photography by Morgan Chidsey-Brosnan, A Sea Of Love
Florals by Venus and Co.
Edited by Hannah Pressley

ISBN: 9781944515775

Printed in Colombia

10 9 8 7 6

To my family and friends
who have helped me grow
into the person I am today.

Hi! I'm Alli.

I am the hands and heart behind Alli K Design. As the owner of my own business, I'm a girl who wears a lot of hats. Depending on the day, I'm either a muralist, a painter, a teacher, an author...I could go on and on, but to sum it up, I'm a visual artist. Most days you will find me in my home office surrounded by cacti, my two cats, and with a large Chick-Fil-A® sweet tea in hand.

Never in my wildest dreams could I have imagined the opportunities that would come from a simple pen and my curiosity and desire to create. What started as genuine interest and self-taught skills in lettering and illustrating led to where I am today. I create art for a living and I also have the opportunity to inspire others to create beautiful things. This is why I am so excited to share this book with you. If you want to know more about me, my art, or the classes I teach, visit www.allikdesign.com.

WHAT'S INSIDE

I always like to start the process of illustrating florals with the idea that nature isn't always perfect, and that's part of what makes nature so beautiful. Therefore, as you begin to work your way through this book, I hope that you will embrace the true beauty of nature with all its variety, differences, and even imperfections, rather than seeking "perfection."

Each chapter in this book focuses on a different floral project, ranging from wreaths and arrangements to creating patterns and digitizing illustrations. Each project is broken into step-by-step instructions for how to draw the relevant flowers and leaves. Further, each step explains how and where to start. You'll notice lines in a variety of colors: green indicates where to start, black shows what to draw next, and gray shows what you have already drawn in the previous step.

My goal is to provide you with the knowledge to take your floral illustrations to the next level and the confidence to pursue a curiosity for creativity beyond the pages of this book. But your creativity doesn't have to stop there. You can apply what you learn in this book to different projects or mediums, such as watercolors.

I can't wait for you to get started! I wish I could be by your side to encourage you in person, but since I can't, let's use #floralsbyhand to stay connected! Post your progress, ask questions, and be confident in your creativity!

#floralsbyhand

8

TOOLS + BREAK DOWN

12

LEAVES

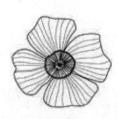

14

A FLOWER SEVEN WAYS

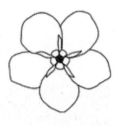

24

FLORAL PATTERN

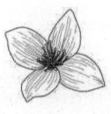

40

FLORAL BUNCH

66

FLORAL WREATH

84

TROPICAL FRAME

112

FLORAL ILLUSION

126

FLORAL WORD ART

146

REAL FLORALS

154

FLORAL ARRANGEMENT

188

DIGITIZE

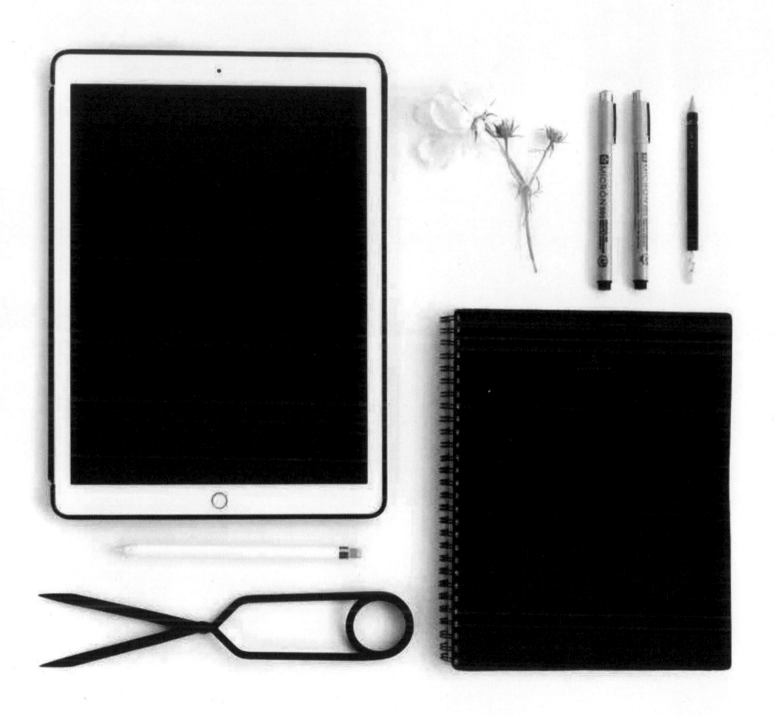

TOOLS

All you'll need as you work through this book is a pen, paper, a computer or iPad®, a scanner, and some flowers for inspiration! The tools you grab first will depend on how you choose to practice as you move throughout this book. You may go old-school with traditional pen and paper or you may choose to go digital from the start. You can practice on the blank pages provided in this book, or you may choose to use your own paper.

You may wish to begin by using a pencil to practice in the spaces provided in this book. If you opt for traditional pen and paper, I do have some favorite tools and materials to recommend. My go-to pens are Micron® or Tombow® drawing pens because they come in different sizes. (I like to use two different sizes for different line weights and to add contrast.) My preferred paper is marker bond paper; I find it is the best when it comes to scanning illustrations. If I'm just doodling for fun or practicing for a project, I'll use computer paper, my planner, or a journal. Moleskin® and Appointed® are two brands that offer excellent journals for illustrators. If you are feeling really crazy by the time you reach the end of this book and you want to add watercolor to your illustrations, I recommend that you use Fabriano® Artistico Hot Press paper.

If you plan to digitize your pen-and-ink drawings, marker bond paper will prevent the ink from bleeding; this will give you the best result for scanning, printing, and sharing your floral illustrations and designs. If you plan to go digital from the start, I suggest using an Apple Pencil® with an iPad. The app Procreate® is a great digital illustration app with amazing features. You could also use a scanner and computer, or even an iPhone® to digitize your illustrations. I use Adobe® Illustrator®. Digitizing your creations may seem daunting and complex, but I'll walk you step-by-step through the process in the last chapter of this book.

LET'S BREAK IT DOWN

Flowers can seem complicated at first glance, and that's because they are! Flowers are a beautifully complex feat of nature. However, illustrating flowers can be broken down into a few simple shapes and lines.

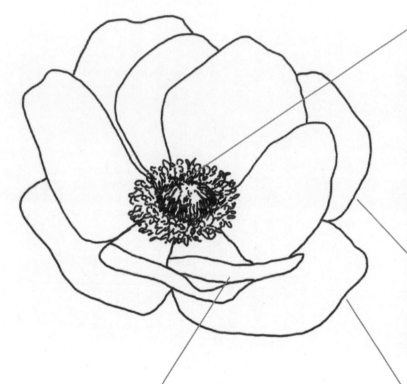

CENTER

Our illustrations will typically start with the center of the flower. The center is often referred to as the "thumbprint" of a flower, with distinct features such as hairlike filaments or dark shading. However, don't overthink this step! The use of simple lines and certain styles of shading is all you need.

C-CURVE

If you can write your ABCs, then you can certainly draw petals and leaves! The sides of most petals and leaves are two simple c-curves.

FOLDS

Folds represent the bottom part of the petal that is folding up and cupping the center of the flower. Flowers bud and bloom in a variety of ways, but they always curve in relation to the center of the flower.

S-CURVE

For a little more shape and definition, an s-curve will do the trick. The tips of most petals consist of s-curves with a small dip or smooth curve that adds variety and helps identify the type of flower you're looking at.

DETAILS

Most of the details I talk about in this book can be simplified into a series of little lines. While the lines are simple, they can also make or break your flower by making your illustration seem dimensional, or by making it seem flat. No pressure, I promise! If done correctly, these lines can represent color patterns, shadows, details, and overall definition.

To start your shading lines, you must first examine each individual petal. Your shading lines must come from or point to the center of the flower. It is common to lose sight of the center of the flower with the petals farthest away from the center, but remember that every petal is connected to the center. Therefore, your shading lines will connect to the flower center, too.

You can use shading lines to make it seem as though the petals are bending over or curling in. To achieve this effect, add curves to your lines to mimic the curve of the bend or fold.

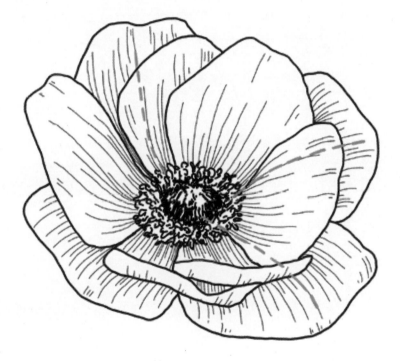

You can add shading lines to your folds, or you can keep the folds blank. If you opt to add lines, you can use simple tick marks. Be cautious that you are not creating a pattern as you add your shading lines. It's easy to fall into the habit of simply alternating between short and long lines, but you want to add lines in a variety of lengths.

Areas where the petals overlap will have more shading lines than petals that are fully open to the light. The closer the lines are to each other, the darker or more shaded that area will appear. Darker shading on overlapping petals also creates definition and separation of petals.

LEAVES

There are many types of leaves, and since the focus of this book is flowers, I will provide you with a simple guide to illustrate basic leaves. As you work your way through this book, some projects will specify the type of leaves to draw, or you can get creative and sketch different leaves altogether. Below, you'll see a variety of leaf types. The opposite pages give simple instructions for how to approach drawing leaves.

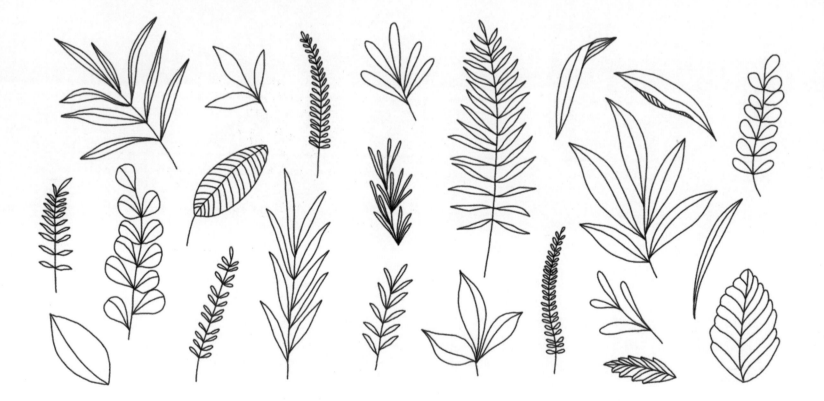

If you are creating a small bunch of leaves, start by drawing your stem.

Leaves are either two c-curves, two s-curves, or a combination of both put together. When connecting the leaves to the stem, make sure the points of the curves connect together where the leaf attaches to the stem.

As you draw more leaves, remember that they don't have to be directly opposite of each other. Add variety to the shape, curves, and placement of the leaves.

When you add details or shading lines, you can keep it really simple, or you can go for a more detailed look by adding more lines. Most leaves will have a central line; this is a good starting point for adding detail. These central lines will also help to define the curve of the leaves.

POPPY

A FLOWER SEVEN WAYS

The beauty of floral illustrating is that there are a thousand types of flowers and countless ways to draw each individual flower. To some, this may be intimidating or overwhelming, but to me, it opens up a world of possibilities. Let the variety in nature inspire you to pick up your pen! No two flowers are exactly alike, just as everyone likely picked up this book for individual reasons. Find your style and stay true to you!

The steps in some of the projects in this book may focus on only one way to draw a certain flower. Remember though: once you have the basic idea and foundational skills, you can get creative and mix things up!

In this chapter, we'll do just that. The following few pages experiment with drawing a poppy flower seven different ways. This activity would make for a great weekly challenge to warm up your brain and get your creativity flowing! Drawing flowers in different ways will help you expand the skills you learn in this book to find a look and style that is unique to you!

POPPY

THE FLOWER OF SLEEP

DAY ONE

Draw a poppy as simply as possible. Start easy. Focus on the
basics. Here is mine. I chose to do a side view, but you could
make it even simpler with a bird's eye view.

DAY TWO

Draw a poppy using as many straight lines as possible. Use minimal curves. It's easy to get caught up in which way a petal or shading line should curve. For this exercise, use straight lines and a boxy look to focus on the basic shape of the flower rather than becoming distracted by intricate curves.

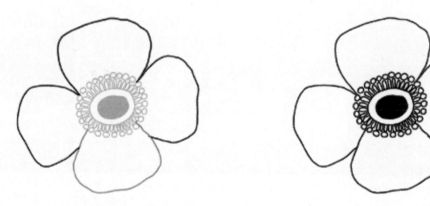

DAY THREE

Throwback! Draw a poppy with as much retro style as you can muster. Keep the petals simple and get creative with the center. Use different shapes and patterns to create a more "retro" center. See how many variations of a center you can come up with!

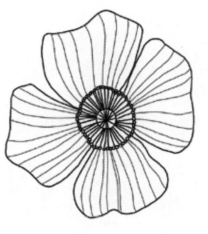

DAY FOUR

This time, get as playful as you want with your poppy drawing!
Don't be afraid to practice adding color to this playful flower.
This version of the poppy would be fun to fill in with color.

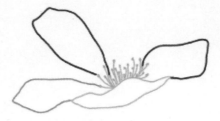
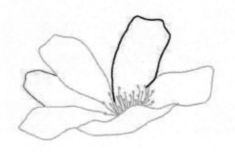
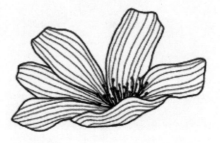

DAY FIVE

Now that you have drawn several versions of the basic poppy,
let's practice with lines and how they impact the movement of
the flower. Focusing on these lines will help you to practice the
shading and detail lines that you will use throughout this book.

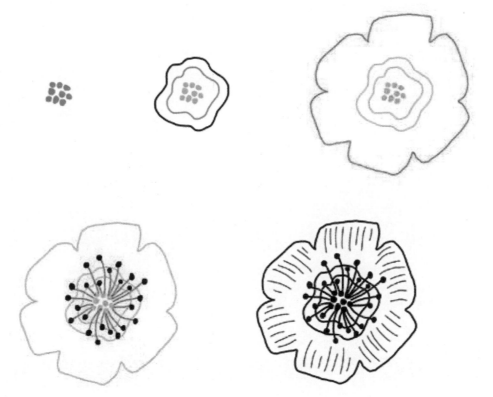

DAY SIX

Next, draw a simple side view with more elegant and directed movement of lines. Use the curves of the lines in this drawing to really accentuate the movement of each petal.

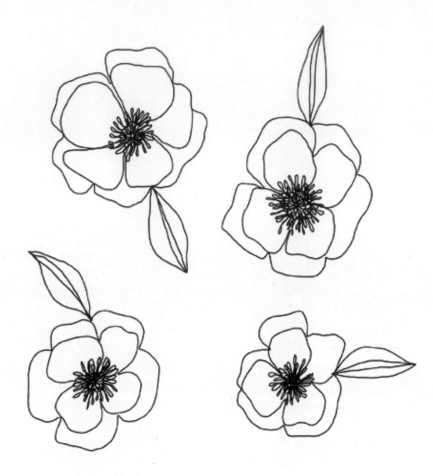

DAY SEVEN

Finally, my favorite challenge: draw a poppy without lifting your
pen or pencil. I can't break this illustration down into multiple
steps since it is technically one fluid motion, so here are a few
examples of my attempts. These are quick sketches that should
take only a minute or less as your pen or pencil glides across the
paper. Try this challenge a few times and compare the different
versions you create!

PRACTICE

POPPY

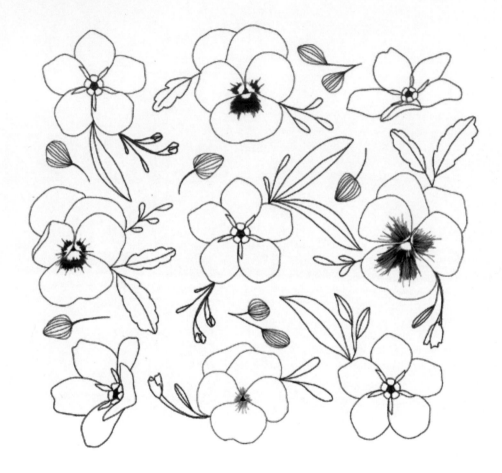

FORGET-ME-NOT • PANSY

FLORAL PATTERN

We've all heard the saying, "You reap what you sow." But people often forget that sowing is work. It takes time and patience to figure out who we are and to grow into ourselves, our passions, and our skills.

As you lay the foundational soil of your life, sow what you hope to reap: things like love, passion, and happiness. Whatever it is you want to grow, work hard at it. If you take time to build yourself, then you can conquer anything.

Nature celebrates patterns: you see them in flowers, in wood grains, even in gardens and farms with organized rows of flora and fauna. Embrace patterns—of work, thought, or behavior—in your own life to grow your skills and build your life into something beautiful.

FORGET-ME-NOT

THE FLOWER OF NEVER-ENDING LOVE

| 1 | 2 |

Start the center of your forget-me-not by drawing a small pentagon shape. Next, fill in the pentagon with five thin ovals; each oval should align with the corners of the pentagon. To complete the center, draw five rounded petals that again align with the corners of the pentagon.

Add five thin, pointed petals to the dips between the petals drawn in the previous step. You'll notice how all of the elements in this bird's eye view of the forget-me-not align with each other. This step completes the whole center of the forget-me-not.

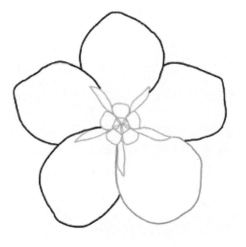

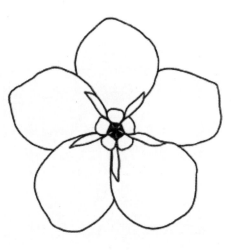

<div style="text-align:center">

3

</div>

<div style="text-align:center">

4

</div>

Starting with the bottom right petal, draw five large rounded petals. Once you have your anchor petal in place, move in a clockwise direction and allow the petals to build off each other.

Finally, go back and color in the blank space in the center of the pentagon that you drew in step one. This last step might remind you of the details of a sand dollar.

FORGET-ME-NOT

SIDE VIEW ONE

1	2

1

Start again by drawing the center of the flower that features the center circle with five small surrounding petals. This side view will have more variation in size and shape than the straightforward bird's eye view. Add three thin, pointed petals to the three dips at the top of the center.

2

Add one large anchor petal that cups or surrounds the center drawn in the first step. Make sure this petal curves and spans the length of everything you drew in the previous step.

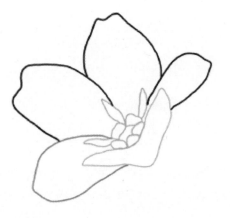

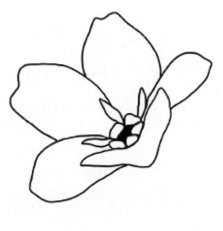

3

4

Add four more petals, starting with the two petals on the sides and filling in the back two petals. The two large petals at the back of the flower should have small dips at the edges.

Finally, go back and color in the blank space in the center of the forget-me-not that you drew in step one. This tiny dark center is a key detail of the forget-me-not.

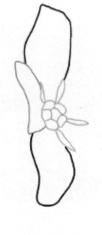

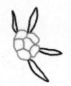

1	2
Start again by drawing the center of the flower that features a circle with five small surrounding petals. Again, the side view will have more variation in size and shape than the straightforward bird's eye view. Add four thin, pointed petals between the dips of the small center circles.	Add one oblong anchor petal at the base of the center drawn in the first step. Add two more petals on either side of the center like wings. You'll notice all three of these petals are unique in their shapes, so draw what feels natural and flowing to you.

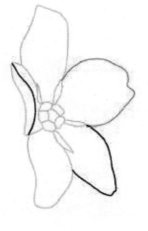

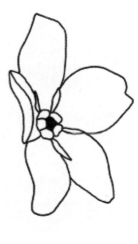

3	4

Add two more petals coming from the top of center. Try to incorporate more details into this step, like adding a dip at the end of the petals and adding a fold to the first anchor petals.

Finally, go back and color in the blank space in the center of the forget-me-not that you drew in step one. The forget-me-not is actually tiny flowers that grow in a bunch. You can illustrate this by drawing several forget-me-nots together, and adding a stem to connect them.

PANSY

THE FLOWER OF LOVING THOUGHTS

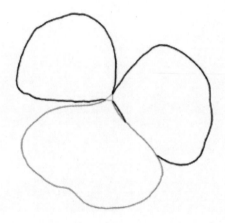

1

The pansy has four simple steps, but there are a multitude of ways to make each pansy unique. To start your pansy, draw a tiny triangle.

2

Next, draw three large, smooth petals that build off the small triangular center.

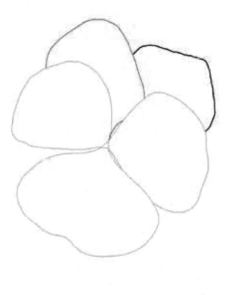

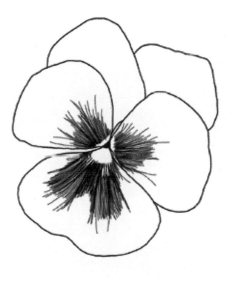

3

Next, add two more petals that peek out from behind the three main petals.

4

Finally, draw a lot of shading lines really close together to create a dark, dense center. Also color in the small center triangle that you drew in step one.

PRACTICE

FLORALS BY HAND

FLORAL PATTERN

The key to making a good pattern is to start with a simple square. Then, you can duplicate the square to make the pattern as large or small as you want depending on how you choose to use the pattern. By filling a small square with your pattern, you can use a grid to expand your pattern into more rows or columns.

Patterns can be used in many different ways. I have used patterns to create custom wrapping paper, personalized fabric, and even backgrounds for a phone or computer screen. Patterns may seem overwhelming at first, but when you break it down, it's one simple square repeated over and over again.

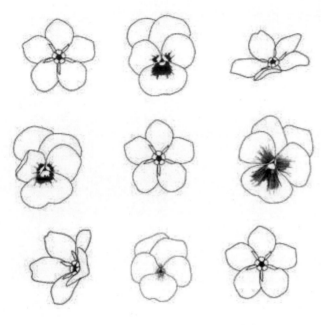

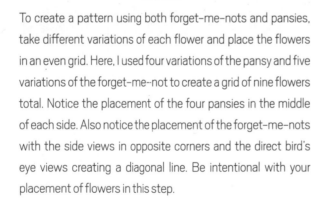

1	2

To create a pattern using both forget-me-nots and pansies, take different variations of each flower and place the flowers in an even grid. Here, I used four variations of the pansy and five variations of the forget-me-not to create a grid of nine flowers total. Notice the placement of the four pansies in the middle of each side. Also notice the placement of the forget-me-nots with the side views in opposite corners and the direct bird's eye views creating a diagonal line. Be intentional with your placement of flowers in this step.

Next, add leaves to your flower to help fill in some of the blank space. (Don't add too many leaves; we still have a few more steps!) Use a variety of leaf shapes and sizes to add unique details to your pattern. Refer back to the leaf page near the beginning of this book for examples of different leaves.

 3

4

In the remaining blank space, add a few small buds. These buds do not have to be connected to any flowers or leaves and instead can seemingly "float" in your extra blank space. Since flowers and leaves already provide a lot of variety in your pattern, I encourage you to keep the buds simple and similar to help create consistency within the pattern.

Last but not least, make that pattern official by tracing everything in ink! You can also digitize your pattern block and replicate it to create a larger pattern.

PRACTICE

FLORAL PATTERN

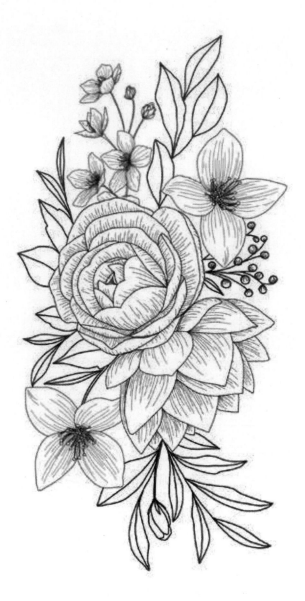

CHERRY BLOSSOM • CAMELLIA • SYRINGA

FLORAL BUNCH

From an early age, handwritten notes in school and hand-picked flowers may be signs that someone likes you. There is something within us that makes us seek ways to let someone know that we care for them; I love that flowers are often a part of this!

There is tremendous power in showing others that you care. In fact, people often won't know that you care unless you take the time to show them through your words and actions. People need to see and feel your passion and heart before they fully give into their own feelings of caring. Find ways to show the people you love that you care. You don't need to be extravagant. Perhaps it's as simple as a handwritten note with a hand-drawn bunch of flowers.

SYRINGA

THE FLOWER OF CONFIDENCE

1

Draw a cluster of tiny circles; the circles should be condensed in the center with random outlier circles further out.

2

Next, connect the tiny circles with small stems that meet toward the center of the circle. It's okay if some of the stems are not visible.

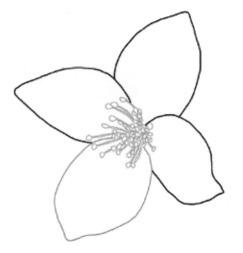

3

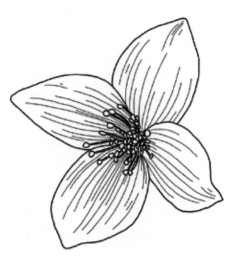

4

Add four petals around the center. Start with the petal on the left. This is the petal that is on top, and all the other petals are overlapping. Add two petals on either side, and finally complete the flower with the petal that is tucked under the other two petals.

Last but not least, add shading lines. Use longer curved lines toward the center of the flower, and smaller curved lines at the tips. Make sure your lines are all different lengths.

LOTUS

THE FLOWER OF MENTAL PURITY

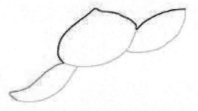

1

To start the lotus flower, we'll use the rule of threes. Draw three small c-curves that will become the base petals. Start with the curve in the center, then add curves to either side.

2

Complete each c-curve from the first step by adding another curved line to the tops. To the leftmost curve, add a dip in the top of the petal. To the center curve, add a pointed tip in the top. And to the rightmost curve, add a simple connecting curve. Remember, variety is an essential part of nature.

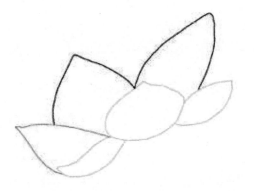

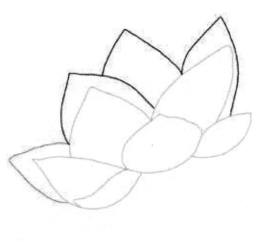

3

In the next few steps, we'll add layers of petals to the base layer created in the previous two steps. Add the next layer by adding three pointed petals in varying shapes and sizes.

4

Add another row of four pointed petals. These petals will appear to be larger, but less of them will be visible since they are "hidden" behind the previous row of petals.

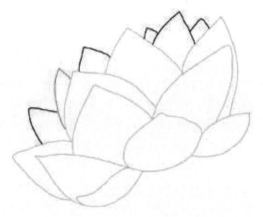

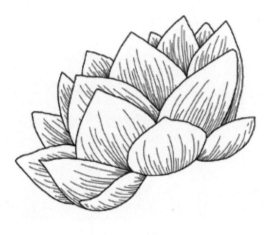

Now, fill in the blank space with just the small tips of petals. This step helps make the flower look more dimensional.

Use a variety of long, medium, and short curved lines to add dimension to your lotus. It is important that you pay attention to the direction of these curves to ensure that they match the curve of your petals.

CAMELLIA

THE FLOWER OF LONGEVITY

1

The center of the camellia is a bit complicated, but don't worry! It gets easier! Start with a small triangle, then connect each corner of the triangle with another smaller triangle inside the first one.

2

Then, connect everything with three c–curves along the bottom and one long curve across the top.

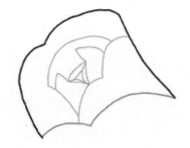

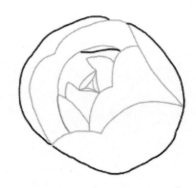

| 3 | 4 |

At the base, draw two small c-curves, similar to how a child might draw birds in the sky. Then, add one big, sweeping line that connects each end, with a small dip where the top of the flower tilts to the left.

Next, add a few small details before rounding out the center of the flower. Draw a final line to the left side of the center and a small line to the dome shape to add a fold near the center. All that's left now is to finish rounding out the center of the flower with two smoother curves that complete the circle.

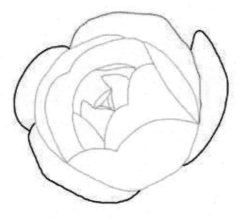

5	6

Now things get a little bit easier. We will be adding petals around the center of the flower. Start with the petal near the top of the flower, then work your way around clockwise, letting some of the petals build off each other.

Add another layer of petals; remember to be organic when it comes to your lines, shapes, and sizes.

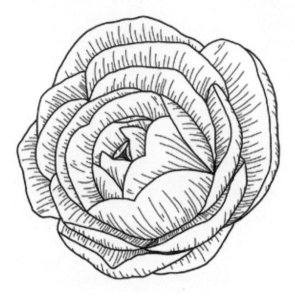

Add a few more petals here and there to fill in the shape, and then add some folds to some petals towards the bottom half of the flower.

For shading, it is important to remember that the petals on the bottom should appear to be folding up whereas the petals at the top are folding out. Your shading lines will always start from the base of the petal, but you'll notice that the petals with folds will have shading lines that start from the opposite direction to give the appearance of folding toward the center.

CHERRY BLOSSOM

THE FLOWER OF RENEWAL

The cherry blossom is a combination of multiple buds blooming from the same branch. Therefore, there are more steps than a lot of the other flowers in this book, but a lot of these steps will be repeated since there are multiple versions of the same flower.

1	2
Our first bloom is tilted downward, so draw several small lines pointing down from a central point with small points at the end of each line. These lines are creating the filaments that protrude from the center of the flower.	Next, add two petals on either side of the center, like mouse ears or wings.

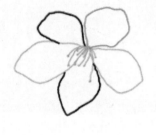

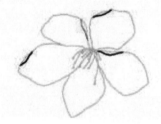

3

4

Then, add two more petals at the top of the flower and one at the bottom. This step finishes the petals.

To add some detail to the petals, add four small folds.

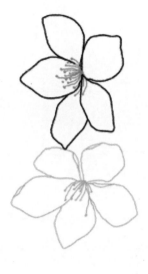

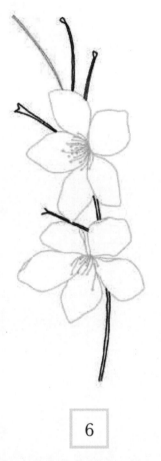

5

The cherry blossom is a combination of multiple buds blooming along the same branch. Repeat the first few steps to add another flower, starting with the filaments in the center and then adding five petals around the center.

6

Connect the first two flower buds by adding stems. Draw one central stem that goes behind both flower buds, then add three smaller stems to the top and one smaller stem to the middle. These smaller stems will eventually have smaller buds blooming from them!

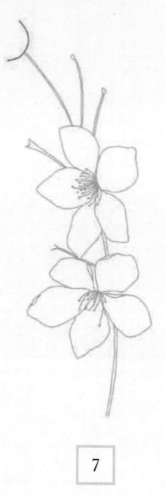

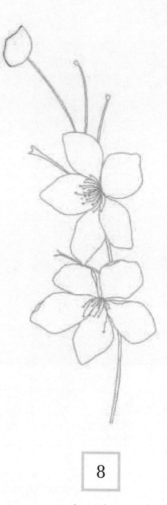

7

8

To begin the first smaller blossom, draw a backwards 'c' at the tip of the longest stem near the top.

Next, add a top or cap to the 'c' drawn in the previous step. This completes one of the five petals of this blossom that is covering up the center of the flower.

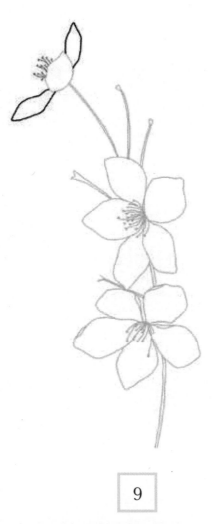

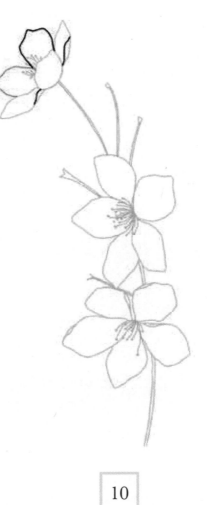

$$9$$

Draw a few small filaments peeking over the top of the petal from the previous step and add two more wing-like petals to each side.

$$10$$

Add two more petals to the top and add two folds to the wing-like petals from the previous step.

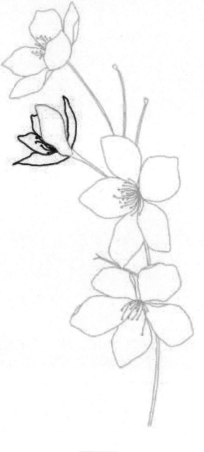

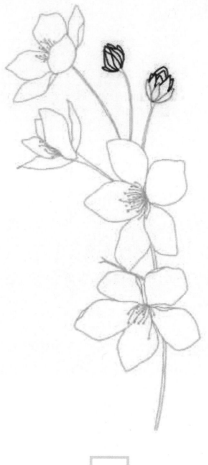

11

For variety, add some flowers in different stages of bloom. Add a flower here that appears to be in mid-bloom. Start with one larger oblong petal. Then add two oblong wing-like petals, and then two petals hidden in the background. You can include a few filaments peeking around the corner of your main petal.

12

You can even add a few buds that are soon to bloom! Do this by drawing a base of three oblong petals to form a cup shape. Then, fill in that cup with triangular, pointed petals.

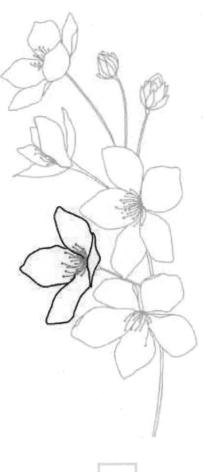

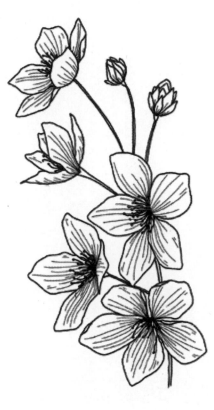

| 13 | 14 |

Add one final bloom to the middle of the flower. This bloom should appear to be pointing to the left. Due to the angle of this flower, only four petals are visible.

And finally, add a few lines of shading to each petal. You may also wish to add some shading lines to some of the small folds and the base of the small buds for extra little details.

PRACTICE

FLORAL BUNCH

Out of all the projects in this book, the floral bunch is the one I draw the most. It is my go-to project because it is typically the easiest to put together. "Bunch" is defined simply as "a number of things, typically of the same kind." Therefore, if you can draw one flower, then you can draw a floral bunch! Floral bunches can be as simple or complex as you want them to be.

You will see floral bunches in other projects throughout the rest of this book. This project is, in a way, where every other project begins. Bunches are more approachable and less stressful than illustrating a flower arrangement. We'll begin with bunches and work our way up to arrangements!

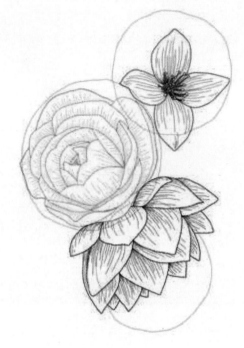

1

Start your flower bunch with three circles that will represent the placement of your three main flowers. These circles should be drawn in pencil and should overlap each other just a bit.

2

The middle flower is the camellia, the lotus is on the bottom, and the syringa will be at the top. Each of these main flowers should point away from the center of the bunch. You may erase the circle placeholders later, after you have drawn your flowers in pen.

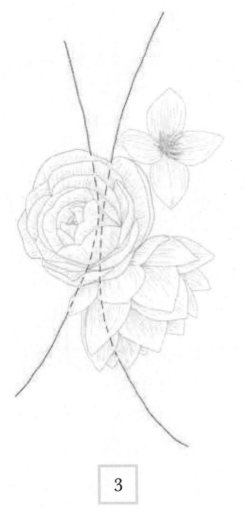

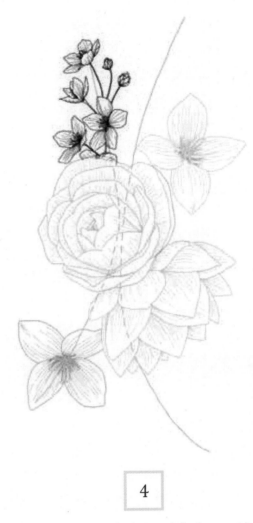

<table>
<tr><td>3</td><td>4</td></tr>
</table>

Using your pencil again, draw a curved 'x' as a guideline for the placement of leaves and flowers for the rest of this bunch.

Place another syringa to the bottom left of your guiding 'x' and add half of the cherry blossom to the top left of your guiding 'x.' (You may wish to rotate your paper as you add your cherry blossom.)

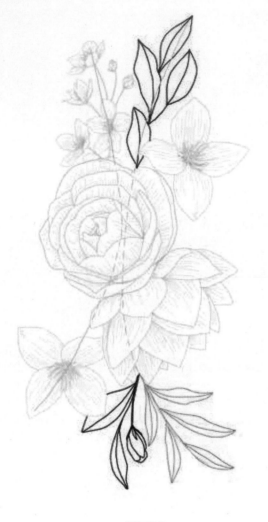

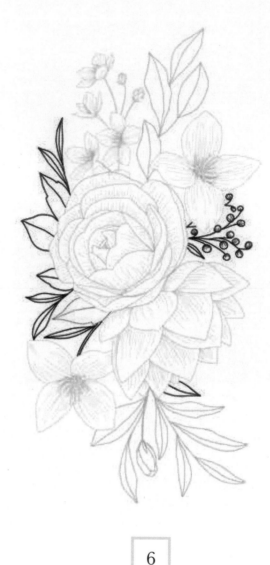

<table>
<tr><td>5</td><td>6</td></tr>
</table>

5	**6**

Next, add leaf bunches to top right and bottom right of your guiding 'x.' Add an additional bud with a few leaves to the bottom middle of your bunch. As you can see, we are slowly filling in the blank space surrounding the main flowers.

Continue filling in the blank space by drawing more leaves to the left side of the bunch, surrounding the camellia. Be sure to include a stem to connect the syringa. On the right side of the bunch, add some berry-like elements in the middle of the three anchor flowers.

7

Finally, trace the permanent details in pen and erase any remaining visible pencil guidelines.

PRACTICE

FLORAL BUNCH

HELLEBORUS • WILD ROSE

FLORAL WREATH

If we were actually together while I was drawing this, you too would have had the Girl Scouts® song stuck in your head. You know the one that goes, "A circle is round, it has no end. That's how long I will be your friend." That's all I could remember from the song at the time, but I belted it out over and over while drawing this circle wreath, thinking about the friends I have made and the ones I have yet to make. The song goes on to say, "We've been friends from the very start. You help me, and I'll help you and together we will see it through."

This couldn't have been a more fitting song for not only this particular chapter that focuses on a circle, but for this whole book. Throughout my career and throughout the process of creating this book, I have surrounded myself with friends and family who love and support me in all that I do. Without them, life would be a little more challenging and a lot less fun.

Surround yourself with people that want to see you grow, people who will shower you with words of encouragement, and people who will shine light on your dreams and help you see them through. I wish more than anything I could be there with you in person to encourage you as work through this book, but know that I am here cheering you on from afar!

HELLEBORUS

THE FLOWER OF SCANDAL

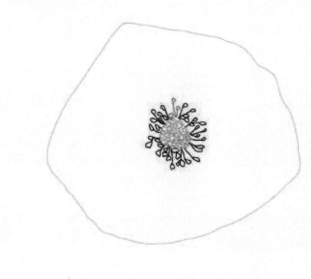

<table>
<tr><td>1</td><td>2</td></tr>
</table>

1

We'll start simple with some imperfect circles. With a pencil, draw a larger circle as a guideline for your petals and a smaller inner circle for the center of the hellebore. You'll be erasing these guidelines later! Next, fill the inner circle with more small circles. None of these circles in this step should be perfect, so feel free to let your shapes be organic here.

2

Next, expand the center of the flower by adding short little hair-like lines with tiny ovals at the ends. Using different lengths for these hair-like details will add variety and realness to your drawing.

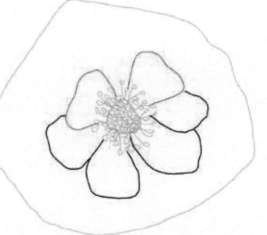

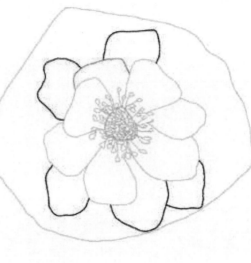

3	4

From the center of the helleborus, add one layer of petals. The petals of the hellebore are very organic shapes. Start by drawing two petals towards the top of the center, as if you are drawing elephant ears. Then, add two more petals on each side, overlapping each petal as you work your way down.

Add a second layer of petals that appear to be behind the first layer. Remember to add variety to your petals, making some boxier, some rounder, and some with dips at the ends.

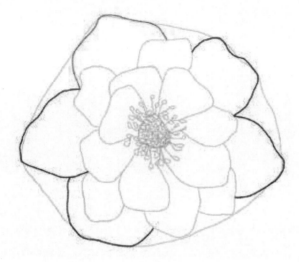

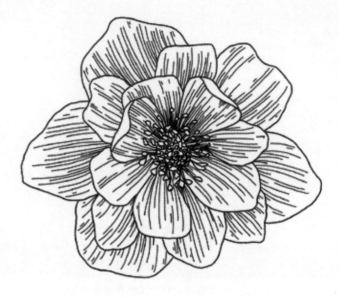

 5

6

Add one final layer of petals to your helleborus. This last layer of petals will be bigger than the previous two layers, mostly but not completely filling in that first guiding circle that you drew in step one.

The last step for each flower is always my favorite — the details! Add some additional lines to some of your inner petals to add a fold and show that your petals are unfolding from the center. Also, give your helleborus more shape by using long c-curved lines to shade the petals. Remember to make these lines curve in whatever direction you would imagine the petals to curve.

WILD ROSE

THE FLOWER OF ADORATION

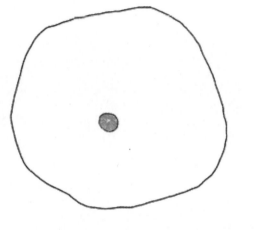

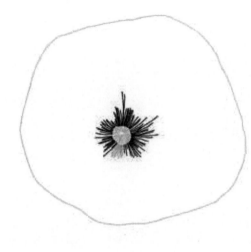

1	2

We'll start simple again with some imperfect circles. With a pencil, draw a larger circle as a guideline for your petals and a smaller inner circle for the center of the wild rose. A wild rose is different from the traditional rose that you might be picturing in your head, so set aside that mental image of a bouquet of roses.

Next, add detailing to your center of your wild rose by first filling in the inner circle with short, thin lines that start on the outer rim and move inward. This will make that inner circle look like a small bulb shape. Then, add a series of longer, thinner lines along the outside of the circle. These lines should vary in length to add variety and realness to your drawing.

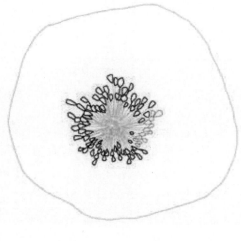

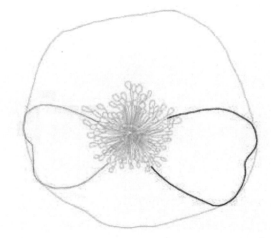

| 3 | 4 |

Continue to add details to the center by adding small ovals to the end of those hair-like structures protruding from the inner circle. Some ovals may be bigger than others and some lines may have more than one oval sprouting off its end.

Next, start the petals by drawing two somewhat heart-shaped petals on the lower half of either side of the center. Don't go full Valentine's Day card here with the heart-shaped petals! A simple, small dip at the end of each petal will do.

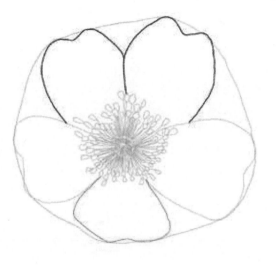

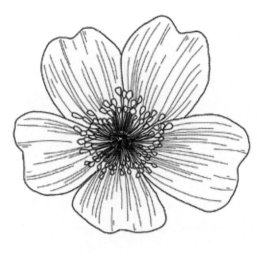

Finish filling out the petals with one petal at the bottom and two more heart-shaped petals at the top. Use the guiding circle from step one to help you with the size of your petals, but don't forget that you don't have to fill in that circle completely. In fact, you can go ahead and erase it once you have your petals drawn.

Finally, include some c-curves on the petals to add dimension. Use a variety of short lines and long lines that curve with the shape of the petal. None of these lines should be straight since flower petals are never straight. You won't need a ruler to draw any of the flowers in this book!

WILD ROSE

1

For our wreath, we're also going to include a side view of a wild rose. Instead of starting with a circle, this time we're going to start the side view with only half of a circle. This starting line should be an organic c-curve that will act as the anchor petal of this wild rose.

2

Now, connect the two end points of your c-curve to complete your anchor petal. Leave a dip in the middle of the petal, similar to the dip at the top of a heart.

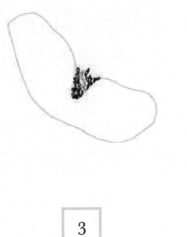

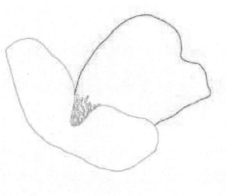
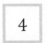

3

In that small dip from the previous step, fill in the space with small little ovals that build off each other.

4

Next, draw a second petal that starts on one side of the center of the flower and stretches to the other side. Make the shape of this petal organic, keeping any imperfections in your curves or the placement of the dip at the tip of the petal.

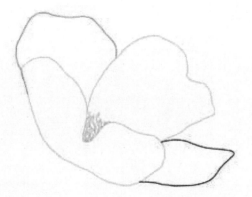

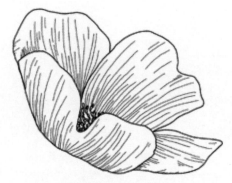

5

6

Add two more petals to fill out the flower, one at the top and one at the bottom. These petals will appear to be behind the first two petals you drew, giving the flower more dimension.

Last but not least, shading! It is really important to use curved lines in your shading to show how the petals fold out from or curve around the center. Use longer curved lines toward the bottom of the petals and shorter curved lines at the end of the petals.

PRACTICE

FLORAL WREATH

You may be familiar with the "Rule of Thirds" in the visual arts. This concept refers to dividing your composition into thirds and placing your focal point within one of these three divisions. This concept is useful when creating a circle wreath.

In this chapter, we will use the Rule of Thirds as you learn how to draw a floral wreath. Helleborus will be the main anchor flower, with wild roses on the front and side as accent flowers.

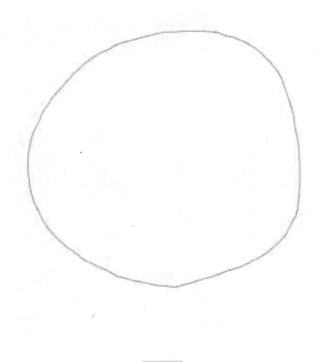

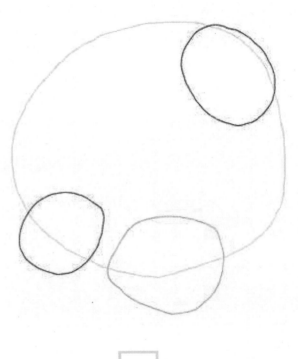

| 1 | 2 |

It should come as no surprise that you are going to draw your circle wreath with—you guessed it—a circle. Draw this step in pencil; it is just going to be a guideline that will be erased later.

Still using your pencil, draw three more circles to indicate the placement of the flowers you will be drawing. The circle in the bottom middle should be the largest, as it will be the focal point of your wreath. The circles on the other sides should be smaller; the circle that will be the side view of the wild rose should be more oval in shape, and placed slightly off-center.

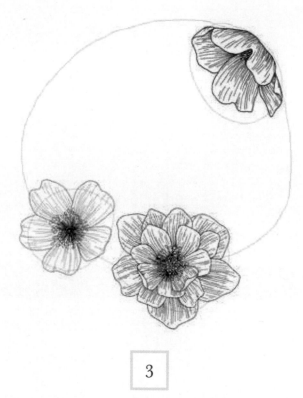

| 3 | | 4 |

Draw the helleborus in the bottom center of the wreath. Next, draw a wild rose to the bottom left of your helleborus. This wild rose should still run along the center of the wreath, but should be slightly smaller. Then, place the side view of your wild rose on the top right of your wreath. The opening of the flower should point toward the inside of the wreath, with the base of the flower placed just outside the edge of the wreath.

Now you're going to start filling in the empty spaces of the wreath with leaves. Start to the right of the helleborus and make your leaves branch off each other until you reach the next flower on the wreath. Draw leaves both inside and outside the main circle. Have variety in the leaves. Some leaves may be individual, some may branch off of each other, and some may be smaller and in bunches.

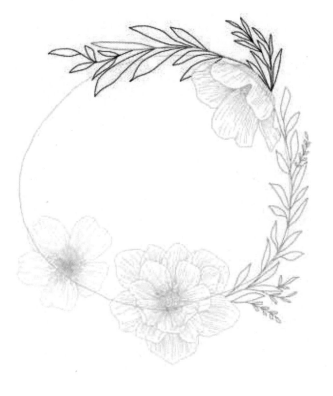

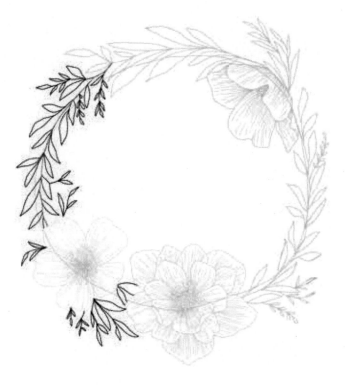

5

6

Continue adding leaves counterclockwise around the circle. The leaves don't have to follow the circle exactly. To make things look more organic, add an extra bunch of leaves to the base of the side view of the wild rose.

Finish filling in the space between the two wild roses with leaves that branch off each other. Add extra offshoots of leaves and some leaves going in the opposite direction of the circle to add some "organic-ness." Leaves often have a mind of their own and will branch off each other in different directions. Don't forget to fill in that tiny space between the two flowers at the base of the wreath.

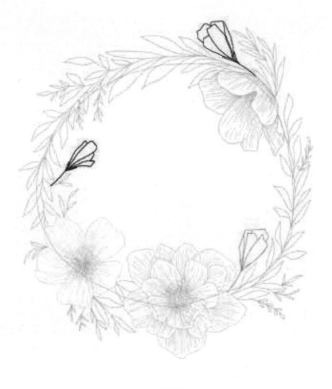

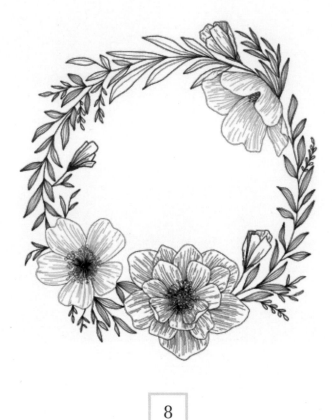

7	8

Fill in your wreath with some floral buds, then erase the pencil circle you drew in the first step. If you drew your flowers and leaves in pencil, trace over them with a pen before you grab your eraser!

You're almost done! The last step is to add shading lines to your leaves and buds. On some of the leaves, stretch the shading lines across the length of the leaf. On others, draw just one central line down the middle.

PRACTICE

———————————

CIRCLE WREATH

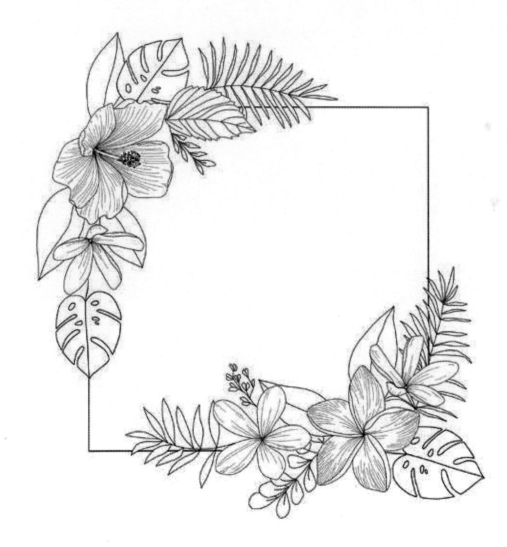

HIBISCUS • PLUMERIA • TIARE

TROPICAL FRAME

You have probably heard the phrase "thinking outside the box," but do you realize that flowers can encourage you to do the same? If left untended, flowers may run wild and become overgrown. If they are overly tended to, they may never fully bloom. There is a special balance between growing and pushing our boundaries, just as there is a balance between playing it safe and becoming stagnant.

It is important in life to sometimes step outside our daily routine. It is easy to get stuck in our own thoughts, opinions, perspectives, schedules, and more. But going outside our comfort zones is often what fosters growth and creativity. Break free of any box or frame or zone that might confine you and dream a little bigger. I always say that cool things happen when you dream big and put those dreams out into the world!

HIBISCUS

THE FLOWER OF FEMININE BEAUTY

1	**2**

The hibiscus is a bright, beautiful, tropical-colored flower with a distinct stem protruding from its center, so we'll start there. Draw a long, skinny vertical stem with a flat bottom and a rounded top.

Then, on the top half of the stem, draw short hair-like lines with tiny ovals at the end.

3	4

Add the first petal to the base of the stem. This will be the smallest petal and it will appear as though it is folding away from the center toward you.

Add a second petal that resembles the shape of a butterfly's wing to the left of the stem. Add a small dip in the end of the petal to add more of an authentic, organic shape.

5

6

Now add a third petal to the right side of the base of the stem. Again, add a dip in the end of the petal, but make it a little larger this time.

Finish filling in the flower with two more petals, moving counterclockwise. These last few petals should appear as though they are at the back of the flower. Therefore, part of the petals should be hidden behind other petals or behind the stamen in the center of the flower.

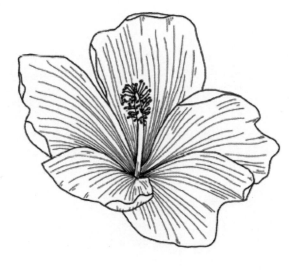

| 7 |

Finally, add dimension by adding small folds to the edges of each petal and curved lines starting from the base of each petal. These curved lines should follow the curve of the petal as it folds away from the center of the hibiscus.

HIBISCUS LEAF

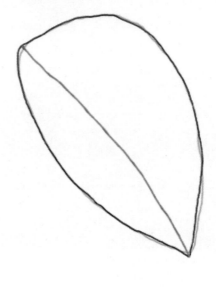

1

Start your leaf by drawing a large, uneven oval in pencil. This will be your guideline. Any leaf that has detailed edges will start with a simple guideline like this.

2

Draw a "central" line down your leaf, but move it to the left of the center. Remember that these central lines will also reflect the curve of the leaf, so don't draw a super straight line. Let there be a slight curve.

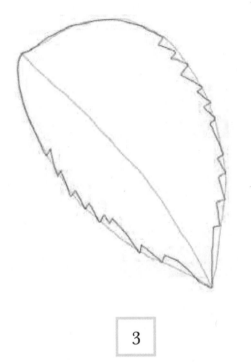

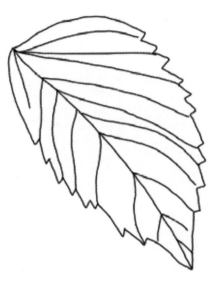

| 3 | 4 |

Go back to the sides of your oval and make them jagged. You don't have to go all the way to the top or the bottom. Instead keep the base and the tip of the leaf a bit more smooth. Use pen for this step and then erase the original pencil oval you used as a guide.

Outline lines that are to be permanent in pen and erase any remaining lines. Next, add veins to your leaf starting from the central line and connecting to the tips of the jagged edges.

PLUMERIA

THE FLOWER OF POSITIVITY

1

The plumeria is a bit complicated, so our first four steps will be done in pencil. Draw a star with five points and a small circle in the center. The circle will be the center of your flower and the points of the star will guide your petals.

2

Still using a pencil, draw your first petal starting at bottom left point of the star. Make sure the petal touches both the center circle and the very tip of the star.

<table>
<tr><td>3</td><td>4</td></tr>
</table>

| 3 | 4 |

Still using your pencil, add two more petals using the same method in the previous step, moving clockwise. Your petals will overlap in the pentagon center of the star.

This is the last step using pencil! Finish adding your last two petals, making sure they overlap toward the center.

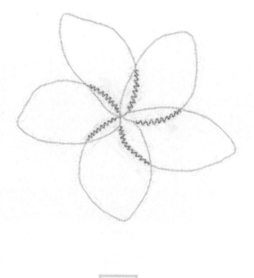

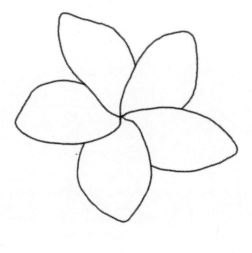

5	6

Now for the tricky part. Now for the tricky part: erase the star that you drew in step one. Also erase the overlapping lines on the left side of each petal at the center of the flower.

This is what your plumeria should now look like! After you erase the guiding and overlapping lines, the petals on your flower should appear to overlap in a spiral motion at the center. Now you can trace over your pencil lines in ink!

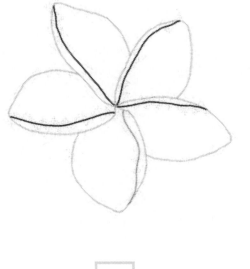

| 7 | 8 |

Along the left edge of each petal, add another curved line to create folds. Make sure all your folds are on the left side of the petals to create a pinwheel effect.

The curved lines in this final step are really important to complete the pinwheel look! Your lines will actually curve in the opposite direction of the folds you added in the previous step. Make sure all of your shading lines curve in the same direction, adding a couple of longer curves to connect the tips of the petals to the center of the flower.

TIARE

This flower also has five petals, but it is much simpler than the plumeria! We'll start with another tiny circle for the center of the flower, with two large petals on either side of the center.

Add two more petals, one to the top and one to the bottom. The base of the petals can overlap some of the other petals toward the center.

3

4

Add one final petal to your tiare, and then you're only one step away from being done!

To give your tiare more shape and definition, use c-curved lines that follow the curve of the petals. Use a variety of short, medium, and long lines to give realistic dimension to each petal.

TIARE

SIDE VIEW

1

For the side view of the tiare, you'll begin with the smallest of the petals. Draw this petal in a small cup shape to give the appearance of the flower tilting to the left. This is the bottom part of the petal, and it will appear to curve up around the center of the tiare.

2

Add a second petal to the left of the base petal. This petal will be much longer and more oblong than the first. Add a tiny circle to represent the center of the flower where the two petals meet.

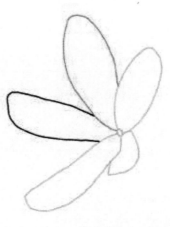

3	4

Add another petal to the top of the tiny circle. This petal should be a little shorter and wider than the petal at the bottom of the flower.

Moving counterclockwise, add two more petals to finish the flower, letting each petal build off the previous one.

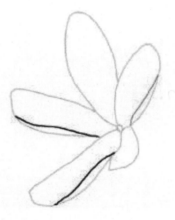

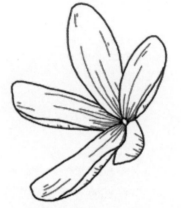

| 5 | 6 |

To enhance the side view, add an extra fold to the three petals at the center of the flower. Each fold should be placed at the bottom of the petals.

Shading for the side view of this flower is a bit tricky. Most of your lines will be toward the very center of the flower, with only a few longer lines stretching across more of the length of the petal. Add a few smaller lines to the tips of and to the folds of the petals. But wait! Pay attention to the direction of the shading lines on the folds and on the smallest petal. They are coming from the side of the petals rather than the center!

MONSTERA LEAF

1

The monstera leaf starts with a simple line. Easy! You'll want to draw these first few steps with a pencil because we'll be erasing a few lines later.

2

On either side of the central line, draw heart shaped sides that mirror each other.

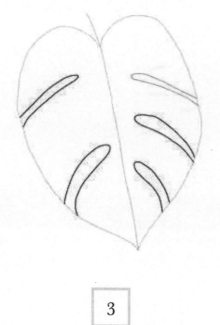

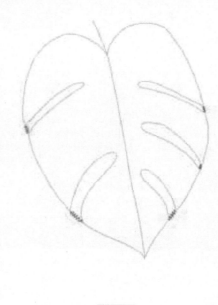

3

Rather than simple veins and lines, you're going to add larger "tiger stripes" to each side of the leaf. Draw two stripes on one side and three on the other side for some variety.

4

Now erase the lines where the stripes meet the edges of the leaf. These stripes are the natural cutouts or notches on the leaves.

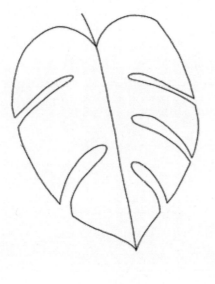

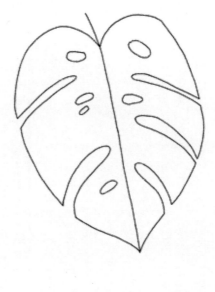

<div align="center">

5

</div>

Next, you can trace over your pencil lines in pen. Use my leaf as reference for what your leaf should look like so far. Then there is just one more detail in the final step!

<div align="center">

6

</div>

Finally, add a few irregular, randomly placed circles on each side of the center. Some of these leaves that have a lot of holes are referred to as Swiss cheese plants!

PRACTICE

TROPICAL FRAME

In this project, we're using only tropical flowers and leaves to add a more festive vibe to the classic square frame. You can use this project to highlight a new photo from a recent vacation, to make a postcard with a tropical border, to frame a favorite quote, or anything else you can dream up! If you're feeling adventurous, try changing up the flowers on your frame to complement whatever content you are framing. Be sure to draw flowers and leaves that pair well together!

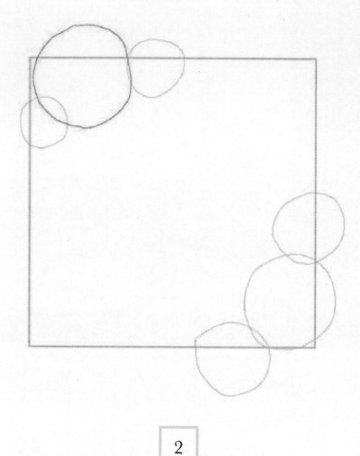

1

2

Now you get to put flowers all together in a square frame. Start by drawing a square in pencil. This will be your guideline, but you'll be erase parts of it at the end.

Next, add six circles to represent placement of the flowers and leaves. Remember the rule of threes in this project, so place three circles at the top and three at the bottom.

<table>
<tr><td>3</td><td>4</td></tr>
</table>

3	**4**

Place a hibiscus in the top middle circle with a pair of leaves on one side and a side view of the tiare flower on the other side. Place your plumeria in middle of the bottom set of circles with a tiare and a side view of a tiare on either side.

Add two more leaves to the bottom bunch of flowers and three more leaves to the top bunch. This will connect the flowers and help to fill in blank space. These leaves can be very simple, with just a central line down the middle that appears to protrude from the base of the main flower in each corner.

5

Add a monstera leaf to each corner bunch, still using the square from step one as a placement guide. Remember the rule of threes: by adding two monstera leaves, you should now have a total of three monstera leaves in the frame—two at the top and one at the bottom. You'll use the rule of threes to add more leaves in the next two steps as well.

6

This time, add three long, skinny, simple leaf bunches to your frame. Add one to the top and two to the bottom, still using the square from the very first step as a placement guide. These longer bunches should follow with the edges of the square and should appear to protrude from behind the other flowers and leaves from previous steps.

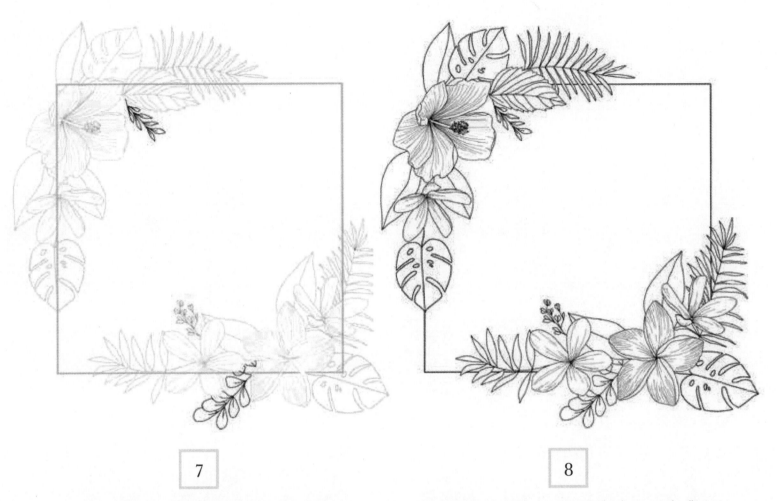

7

Add one more group of three by adding three smaller leaf-bunches to your frame. Add one to the top and two to the bottom. These do not have to follow the square, rather, they can protrude a bit from behind the other flowers to fill in some blank space.

8

You can either erase the square completely to give the illusion of a square or you can trace the remaining visible edges of the square in pen and erase any lines that are now covered with leaves of flowers. Two corners should still remain distinct, while the other two should be erased and replaced with the bunches of leaves and flowers.

PRACTICE

TROPICAL FRAME

FLORALS BY HAND

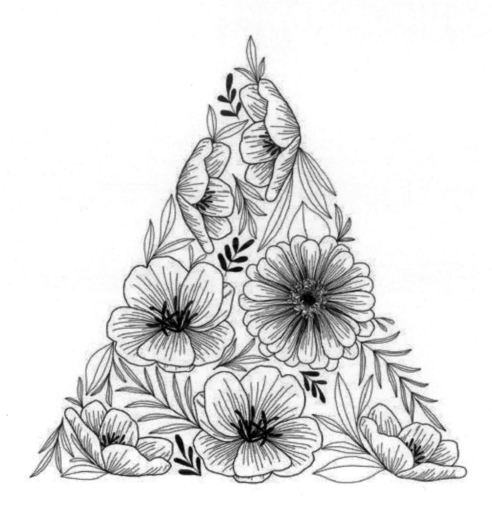

ZINNIAS • EVENING PRIMROSE

FLORAL ILLUSION

As children, we're taught to not judge a book by its cover. We learn that both people and books are about what is inside. As we grow up, we may realize the importance of this lesson in a very personal way if we are ever judged by how we look.

It's important to remember that everything and everyone has a story and a journey. Know that what you see may not be the whole story, so always give people the benefit of the doubt. When I look at a flower, I am reminded of this idea by the details in each individual petal and leaf. The center of a flower is often compared to a human thumbprint; both uniquely reflect identity.

ZINNIAS

1

2

Start your zinnia with a small circle or wreath of tiny blossoms. Each tiny blossom will consist of four or five petals. Use a variety of lengths, curves, and angles to add detail to the complex center of this flower.

Next, create a smaller ring of even tinier petals inside what you drew in the previous step. This detail will appear more like small circles in pairs surrounding a dark, dense center. To create this illusion of a dense center, use many shading lines that curve toward the center, making the very center look a bit like a tiny lion's mane.

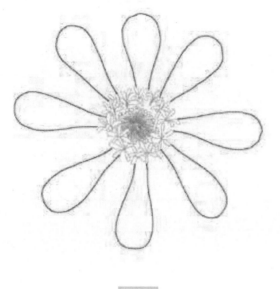

3	**4**

Add eight petals around the center. These petals should be evenly shaped and evenly spread out around the flower. While the center of the zinnia is complex, the petals are rather uniform.

Continue with the petals by adding a series of similar petals behind the petals drawn in the previous step. While these petals do overlap, you'll notice that the majority of them are still visible.

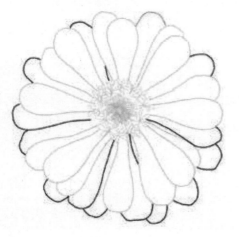

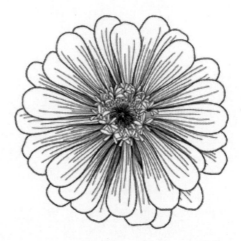

<div style="text-align:center; border:1px solid #000; display:inline-block; padding:4px 12px;">5</div>

Add one more series of similar petals to fill in any remaining empty space around the center of the flower or edges of the petals. Some of the petals in this step may be barely visible; just make sure any blank space is filled.

<div style="text-align:center; border:1px solid #000; display:inline-block; padding:4px 12px;">6</div>

Each petal should have a few shading lines that vary in length. Just as these petals are similar in shape, they are also similar in shading.

EVENING PRIMROSE

THE FLOWER OF FAITHLESSNESS

1	2
Start the center of the primrose with a series of thin, elongated ovals sprouting from one main point. These spouts may be seemingly random in shape or direction, but the majority of them will corne from one central location.	Next, add two main anchor petals to either side of the center. One petal may be ovally in shape, while the other may be more triangular.

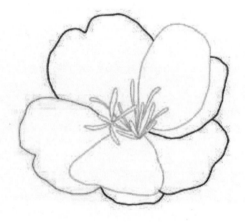

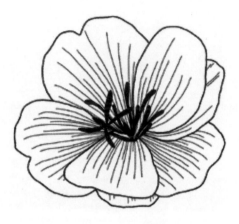

| 3 | 4 |

Fill in the rest of the flower with petals. Some petals will be larger with small dips in the end; some petals will be more hidden behind others.

Fill in the center sprouts with a solid color and add shading lines to each petal. Remember that your lines should vary in length but should all point back toward center of the flower.

EVENING PRIMROSE

1

For the side view of the primrose, first create one long c-curve that will act as the base of two petals. Next, add another c-curve and an s-curve on top that will overlap in the middle. These two petals will act as a "cup" for the rest of the illustration.

2

Add details from the center of the flower by drawing small, thin "sprouts" protruding from the center near where the two petals overlap. You will not be able to see the whole center of the flower from this side view.

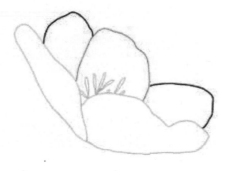

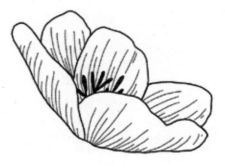

3	4

Add one large petal at the center of your illustration, directly behind the center sprouts from the previous step. Then add two more petals to either side to finish the petals.

Finally, fill in the center sprouts with a solid color and add shading lines to each petal. Even though this is a side view of the primrose, the shading lines should still vary in length and should all point back toward the base of the side of the flower.

PRACTICE

FLORAL ILLUSION

One of the most versatile projects is the floral illusion. "Illusion" may conjure the notion of deception, which may be off-putting to some people. However, the words "illusion" and "illustration" share similar roots.Whereas an illusion is likely to deceive, an illustration offers explanation. When we combine these two elements into this project, we're using small floral illustrations to give the appearance or illusion of some of the most basic shapes.

We start this project with a simple triangle, but you can get creative and use other shapes as well. For example, numbers, letters, or states make great floral illusions. This project is a great way to give life to something that is typically seen as basic. Any shape can be created and enhanced with the flowers you have learned to draw!

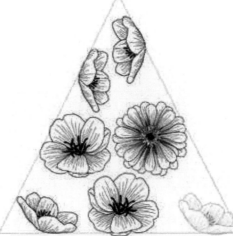

| 1 | 2 |

This may be one of the only times you want to grab a ruler. Start your floral illusion by drawing a triangle in pencil. Since we have already experimented with circle wreaths and box frames, we're going to use a new shape this time. You are welcome to try other shapes as a variation of this project!

Add in a larger front view of your chosen flowers to fill the center of your triangle. These will be the main focus of your illusion. Next, add several side view flowers to fill in the corners of the triangle. It is okay if some of the curves of the petals fall outside the edges of the triangle. In fact, this helps to achieve an organic shape for the flowers you are drawing.

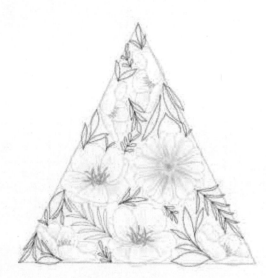

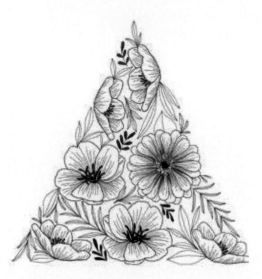

3	4

Fill in any excess blank space with a variety of leaves; get close to the edges and corners of the original guideline to fill in as much space as possible. Again, it is perfectly okay if some of the curves of your leaves do not align precisely with the straight edges of the triangle.

Finally, add details to your leaves by adding central lines to some and filling in others with a solid color. The solid leaves and darker centers of the flowers should be spread out to create a good contrast of light and dark throughout your illusion.

PRACTICE

FLORAL ILLUSION

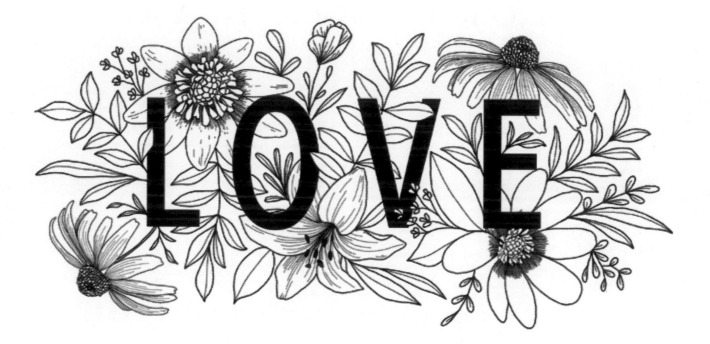

CELANDINE • LILY • BLACK-EYED SUSAN

FLORAL WORD ART

Anyone who knows me knows that I surround myself with a jungle of plants and flowers. I especially love cacti. I freely admit that my love of plants has perhaps crossed to an obsession as they overtake my home and studio, but there is a special joy that comes from surrounding myself with the things that make me happy.

In fact, beauty and sources of joy are all around us. For some (like me!) beauty and joy may be found in plants. Take time to notice the beauty that surrounds you, to enjoy life and show yourself some love along the way.

In my mind, the only thing better than stopping to smell the flowers is taking the time to draw them. Taking time for what we love allows us to appreciate life. When we slow down to take in beauty and when we intentionally surround ourselves with whatever (or whomever!) brings us joy, we allow ourselves to embrace and love the life we are living.

CELANDINE

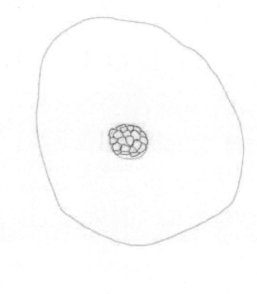

1	2

Start this flower by drawing a small circle to represent the center of the flower. Draw a larger circle around the center to act as a guideline for your petals. Use a pencil for these two steps since you will erase these guidelines later.

Fill in the center of the circle with small, scale-like shapes. These shapes should vary in width and size and should appear to build off each other.

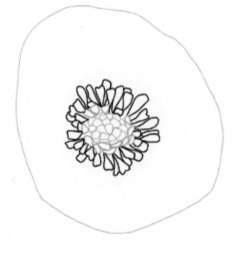

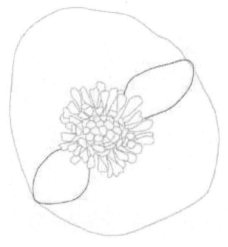

<div align="center">

3	4

</div>

Add one smaller layer of seed-like shapes around the center of your flower. Some of these shapes may be more flat and others may be more triangular or square. The more variety, the better. Using that layer as an anchor, add another layer of larger "petals" protruding from the center. These petals are skinnier at the base and more shapely at the top, either involving a rounded tip or a dip at the edge.

Add two petals to either side of the completed center. These two petals do not have to be equal in size or width. Make the edge of the petal align with the circle drawn in pencil in step one.

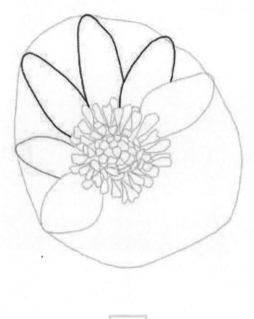

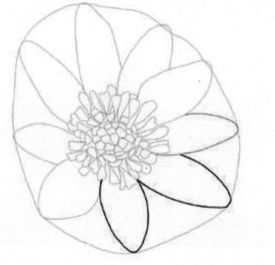

<div style="text-align: center;">5</div>

Starting with the anchor petal on the left, move clockwise and fill in the top half of the flower with more petals. These petals can slightly overlap at the base to add depth.

<div style="text-align: center;">6</div>

Now starting with the anchor petal on the right, move clockwise and fill in the bottom half of the flower with more petals. Remember to make the tips of each petal touch the edge of the guiding circle.

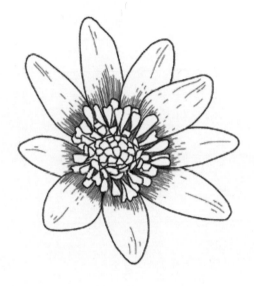

7

To give the illusion of a darker, more shaded center, create
a dense layer of shading lines around the very center of the
flower. Then, use only a few shading lines at the tips of the
petals to contrast with the darker center.

CELANDINE

1	2

1

Yep, this is the same flower, just from a different view. Start this viewpoint with a small circle composed of small scale-like shapes. These shapes should vary in width and size and should appear to build off each other.

2

Add a few more layers to the center of your flower, using a variety of shapes to add more definition. Some shapes may look more like small rectangles or triangles, while others may be longer and skinnier as they protrude away from the center. The more variety, the better. Add in even more detail by adding a dip at the edge of some.

3	4

Add two long, wing-like anchor petals on either side of the center of your flower. These "wings" don't have to be the same shape. This would be problematic for an airplane, but it's good and organic when it comes to flowers.

Fill in one side of your flower with more petals between the anchor petals from the previous step. You may make these petals lean more toward one direction since this is a different angle.

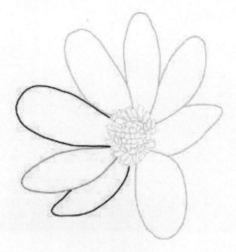

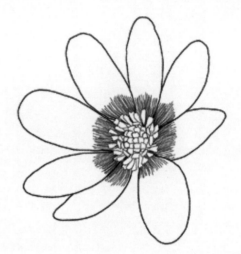

5	6

Add a few more petals to the other side to finish the flower. Some petals may be a bit smaller and tucked behind others.

To give the illusion of a darker, more shaded center, create a dense layer of shading lines around the very center of the flower. The closer together your shading lines are, the darker the center will appear.

LILY

THE FLOWER OF DEVOTION

1	2

The center of the lily is comprised of small hair-like structures, not unlike the cattails you might see at the edge of a river. All of these lines should start from the same central location.

To finish drawing the center, add small seeds to the end of the lines from step one. The shapes of these seeds can vary.

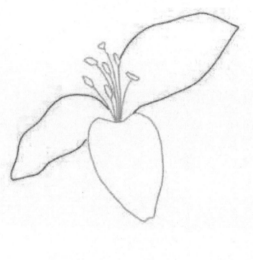

3	4

Draw one main anchor petal at the bottom of the center filaments. The petal should have a small dip at the top where it cups around the center drawn in step one. At this point your illustration might resemble a carrot more than a flower!

Add two more petals to either side of the center of the flower. You may notice that the petals seem to be connecting to the same point as the lines from step one.

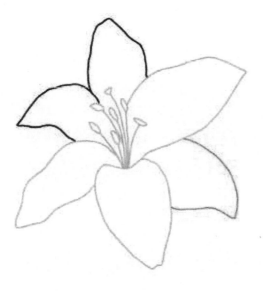

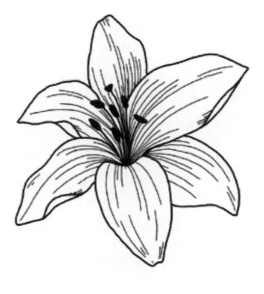

| 5 | 6 |

Finish the main part of the flower by adding a few more petals. These petals will appear to be behind the other petals and behind the center details.

To finish your lily, add shading lines that all curve toward the very center of the flower. Your shading lines may overlap with your detailing in the center, but don't worry. This will create the illusion of a deep center from which the petals are unfolding. Add a few extra details by drawing some folds on a few petals and coloring in the seed-like structures from step two.

BLACK-EYED SUSAN

THE FLOWER OF ENCOURAGEMENT

1

Start your flower by drawing a circle as an outline for the center of the flower.

2

Next, fill in the circle with very tiny circles or ovals. Start at the bottom of the center circle and continue moving up until the circle is filled in.

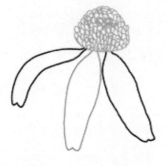

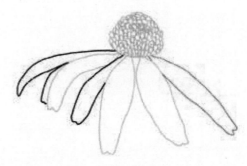

3

Draw three petals coming off the bottom of the center from the previous steps. These long, thin petals will have small dips in the edges. Start with the petal in the center to help with spacing.

4

Add more petals, filling in the space between the anchor petals in the previous steps. These petals will all appear to be drooping, or almost falling off the flower.

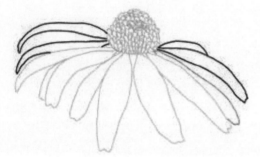

5	6

Add a few more petals to either side of the center of the flower. These petals may appear to be thinner or flatter due to the angle at the edge of the flower.

Finally, use shading lines that extend the length of the petal to accentuate the curve of the petals.

PRACTICE

FLORAL WORD ART

For this project, the hardest part always seems to be the word itself rather than the flowers. Find a word that is important or meaningful to you and give it a little upgrade. Floral word art involves a good mix of the straight, bold lines of the letters combined and contrasted with the loose, free curves of the flowers. The result is a simple but beautiful and striking message.

This project may be the one I am most known for. I love to get creative and blend words and flowers together to create something new. From cards to logos to murals, floral word art allows you to upgrade a word or message and draw attention in ways a simple text message could never do.

LOVE

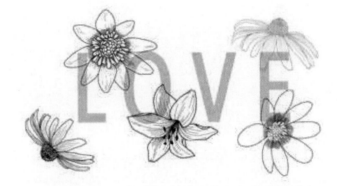

Start with your chosen word. You can print a word from a computer, use marker bond paper to trace the word, or simply draw your own word with a pencil, using grid paper to keep your lines straight.

2

Using a pencil, add in all of the large flowers. Begin by placing flowers in the corners, and then add one near the middle. The placement does not need to be precise, as you want the design to have a loose, organic look and feel.

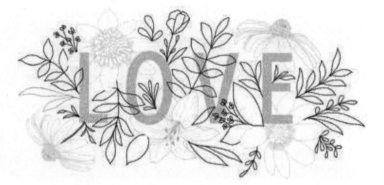 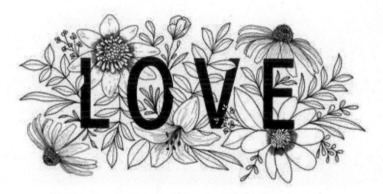

3

Next, begin filling in the space with leaves. You might be thinking this is a big jump from the previous step, but just take it one leaf or one detail at a time. Make your leaves vary in shape and point in different directions.

4

To finish your word art illustration, grab a pen and an eraser. You can either erase the pencil marks outlining your word or you can fill in your word with a solid color. Either way, leave most of the leaves behind the letters, but keep some of the details in front of the letters. Outline the rest of the final illustration in pen, while also adding in the central lines for your leaves.

PRACTICE

FLORAL WORD ART

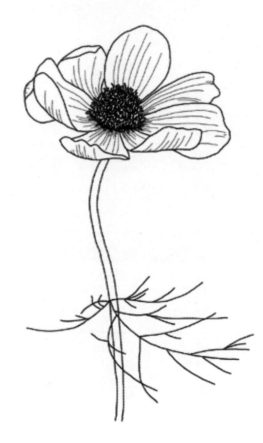

COSMO

REAL FLORALS

I draw all of my inspiration from real flowers. Since Mother Nature is always doing such a beautiful job, I prefer to start with real flowers rather than looking at other illustrations.

Drawing from nature helps me stay true to my own style instead of being heavily influenced by someone else's style. Often, we may subconsciously draw similarly to someone whose work we have studied. Using real, tangible flowers as a starting point helps me to avoid this.

Now, I realize I may sound a bit contradictory since you are currently working through this book that teaches you my techniques for drawing different flowers. However, it is my hope that you will learn how to "see" flowers and learn basic floral illustrating skills so that you can develop your own unique style.

COSMO

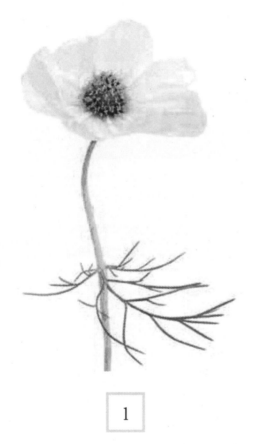

<div style="text-align:center;">

1

</div>

Find a real flower or take a photo of a real flower. Look in your own garden, at a local nursery, or even at the grocery store.

<div style="text-align:center;">

2

</div>

Break the flower down into its most basic shapes. These shapes will become your guidelines for the main parts of your illustration including your center, petals, stems, and leaves. You can either draw these basic shapes in pencil to erase later once your final illustration is traced in pen, or you can just keep this guide to the side for a visual reference.

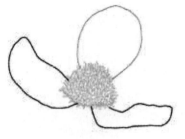

3

When adding details, start with the center of your flower. For the center of a cosmo, I used a series of circles and tick marks in different angles to create a dome-like shape, similar to a gumdrop. The circles and lines in the center should not all be even; make some stick out so the details are more realistic.

4

When drawing the petals, always look for the petals that are at the top first. These petals don't have any other petals overlapping, so they will be the anchor petals.

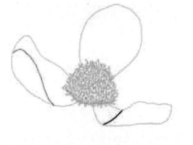

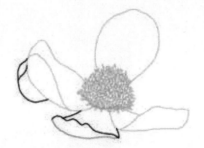

5

Next, add a few folds to these anchor petals. Refer to your real flower or photo from step one. Really look at your flower and notice the way it folds and curves when adding this step.

6

The petals that are beneath or behind the anchor petals are a bit more complex. First, draw the base of the fold with a simple curve. Then, draw the top of the fold with an extra wavy line. Next, draw the petal sides going connecting them back towards the center. Add a few more small petals and folds behind your other anchor petals.

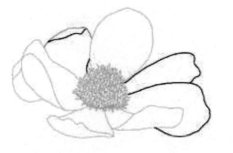

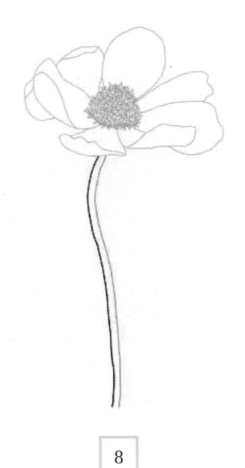

7

Continue this process of adding petals and folds until the blank space surrounding the center of the flower is filled. Not all petals will have folds; remember to refer back to your original flower or image to determine where to place your petals and which petals should have folds.

8

When you draw the stem, remember that it too connects to the base of the center of the flower. Depending on the flower you choose, your stem may be as simple as two parallel lines.

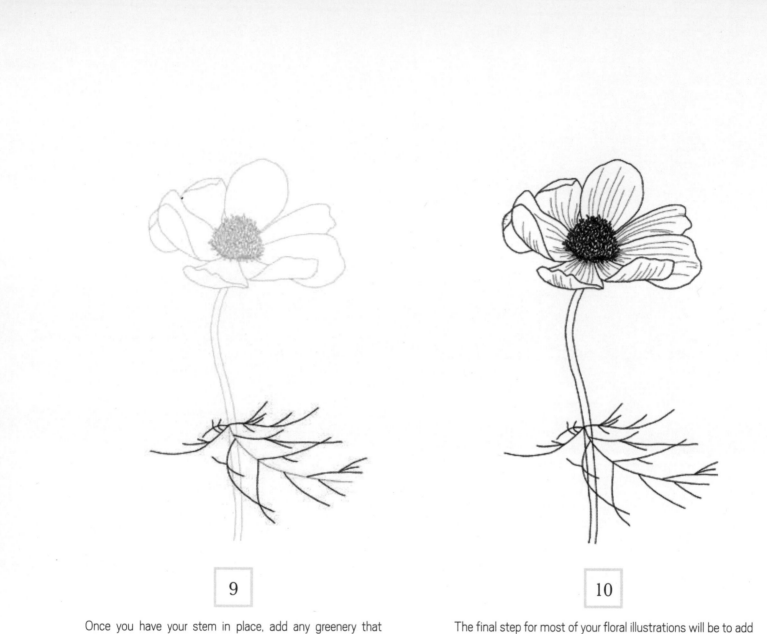

<table>
<tr><td>9</td><td>10</td></tr>
</table>

9	10
Once you have your stem in place, add any greenery that complements your flower. For my cosmo, I added simple greenery consisting of thin lines that branch off each other. Other flowers may include more detailed leaves or buds.	The final step for most of your floral illustrations will be to add shading. Remember to use a variety of lengths in your shading lines for more realistic dimensions. Shading lines can represent color patterns, shadows, details, or overall definition.

PRACTICE

COSMO

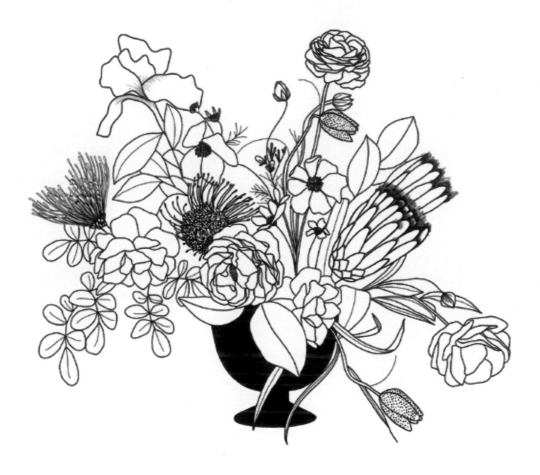

RANUNCULUS • GARDEN ROSE • FRITILLARIA
PINCUSHION • IRIS • QUEEN PROTEA

FLORAL ARRANGEMENT

Life can be overwhelming at times. It can feel as though we are being pulled in a million directions at once. I try to take life in small bites. When things are complex, try to make them simple. I use to struggle with endless to-do lists, always feeling behind and waiting to do "life" once my list was checked off. In truth, that will never happen. There is always a list.

In your daily life, prioritize the top three things on your list, and focus on these first and foremost. This strategy helps me to find joy in my work and to avoid burnout. I am able to focus my mind on what I am doing rather than constantly thinking ahead to the next item on my list.

When you embrace simplicity in a chaotic world, you eliminate the unnecessary things distractions from what's really important. Life can be as simple or complex as you allow it to be. Remember that only the truly important people and things should be at the forefront of the arrangement of your life.

RANUNCULUS

THE FLOWER OF CHARM

1

The ranunculus has lots and lots of petals, so be prepared for a lot of steps that involve adding petals, folds, and such. Draw a slightly curved line, then wiggle your pencil around in a larger c-curve to connect the two ends of the anchor petal.

2

Add two or three more petals; start at the bottom left and wiggle your pencil around clockwise as you add curvy petals.

3

4

Draw a large, elaborate curve toward the middle of the flower. This represents the petals that are unfolding on the other side of the flower, toward the back. Surround that large petal with a few more curved petals.

Add a few small folds to the petals drawn in the previous steps, then continue to fill out the circular shape of the flower by adding a few more simple curves to create smaller, simpler petals. The petals added in this step should appear to be hidden behind others.

| 5 |

| 6 |

Again, return to a few previous petals and add in a few small folds for more detail. Then, start at the top of your illustration and move clockwise around the flower, wiggling your pencil to add another layer of curvy petals all the way around the flower.

As I said, the ranunculus has A LOT of petals, so we still have a few more layers to add! In this step, add a layer to the base of the flower. Include several folds on the petals at the base of the flower since these petals are curving up and around, cupping the rest of the flower.

| 7 | 8 |

ONE MORE LAYER! This is our last row of petals. These last few petals are a bit bigger and looser. These petals are unfolding from the center and should be nice, organic shapes.

You made it! Now that you have all your petals, go back over your lines and curves, paying special attention to the folds of the petals. In the very center of the flower, add in small oval-shaped details. Start at the base of the "center" and work your way up until the center is filled in.

RANUNCULUS

1	2

The side view of the ranunculus may be a bit easier than the straightforward view. Start with a simple c-curve. While this may look like it will be the main anchor petal at the base of the flower, it is actually going to be the center of the other petals we will add. Add a line with a fold to the top of the c-curve to "close" it. From here, we'll be adding lots and lots of petals.

On the top of the anchor petal, add layers of small petals. These petals should have a similar cupped shape, using pointed tips on the edges. This series of petals will act as the center of your flower.

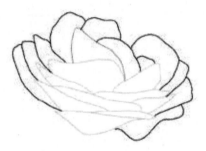

3

4

Add another layer of petals all the way around your flower. Notice how the petals on the side are smaller and more layered and the petals on the top are rounded and more visible.

Add a small fold to each petal along the sides of the flower. Remember that this is a side view of the ranunculus, so all of the petals curve up and around the center of the flower.

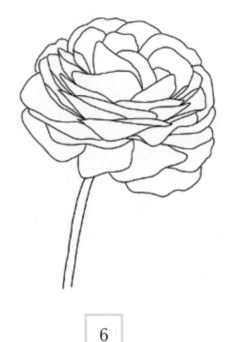

The final step is easy: draw a simple stem! Also, go back and look over your petals, making sure the folds and curves are moving in the right direction. The petals closer to the center should curve upward and the petals further away should unfold away from the center.

Add one final layer of petals to the base of the flower. These petals will not have folds because they should appear to fold away from the flower. This is the outer layer of petals, so they will be more visible and boxier.

RANUNCULUS

1

Start this view of this ranunculus with one large anchor petal. This petal will be a somewhat rounded triangle that we will build on with more petals in the next steps.

2

Remember, the ranunculus is famous for its number of petals. Add three more petals that build on your anchor petal and each other.

3	4

Add another petal that curves around your original anchor petal and then add a fold. Next, add a few more rounded petals to the side of your illustration.

Add another layer of petals to the base of your flower. Each petal should build on the others to create the layered look of the ranunculus.

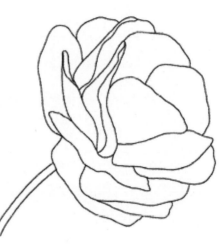

<div align="center">

5

6

</div>

Examine your petals and look for areas to add folds. Remember that the folds should be placed on petals that curve up toward the center. Because this is a side view of the flower, we can only see the petals and can't see the actual center.

Trace your final illustration in ink and add in a stem to the base of the flower!

GARDEN ROSE

THE FLOWER OF INNOCENCE

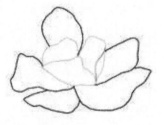

1	2

This garden rose is a very loose flower with petals that unfold in a wide, open way. Start this rose by drawing a triangular base petal and adding two petals on top of the base petal. For this flower, use very organic and unique shapes when it comes to the petals.

Add a fold to a petal from the previous step and draw another layer of petals. No two petals should be exactly alike in shape. Instead, let your pencil just flow.

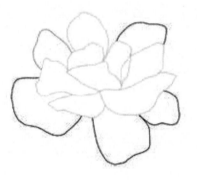

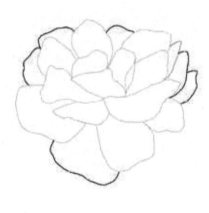

| 3 | 4 |

Add another layer of petals. Start with one petal and work your way around counterclockwise, adding in petals wherever you feel there is a gap.

Add one more layer of petals to finish filling out the flower. Your flower doesn't have to end up a perfect circular shape, but should instead be raw and organic, just like the petals.

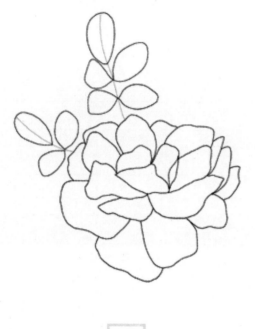

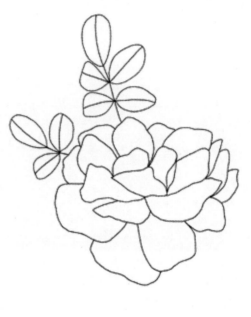

5

6

Draw a few simple stems with basic leaves attached. Since this flower is already unique in shape, you don't have to add too much extra detail.

The last step is to add central lines to the leaves. On to the next flower!

FRITILLARIA

THE FLOWER OF PATTERN

1

2

This flower is simple, yet incredible and unique. Start with one oval anchor petal that resembles the shape of an almond.

Next, add two petals to either side of the almond-shaped anchor petal. These two petals almost look like the pointed tips of cat ears peeking out from either side.

3

Add just the tips of a few more petals to the top of the flower in a way that makes them appear to be coming up from behind the other side of the flower. Add a simple stem to the base of the flower.

4

Instead of the traditional shading lines like we've been drawing, this particular flower appears to be covered in small polka-dots. If you look very closely though, you're still going to use a series of very small lines that are very close together to give the illusion of these "polka-dots."

PINCUSHION

| 1 | 2 |

The center of the pincushion resembles a very tiny tree with a short trunk and two rows of small leaves across the top. This structure will act as the base for some unique "petals" in the next step.

Long tentacle-like filaments protrude from the center of this flower. Start with three to help with spacing, and then fill in the space between. Most of these "tentacles" will connect back to the center of the flower, but some may actually branch off each other.

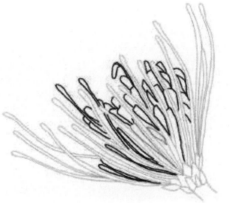

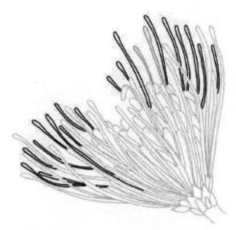

| 3 | 4 |

Continue to fill in some of the blank space with tentacles that are a bit wider or rounder. Add more of these toward the center of the flower to add density and dimension.

Now, continue to fill in some of the blank space toward the outer edges of the flower, extending some of those elongated structures upward.

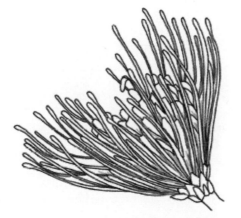

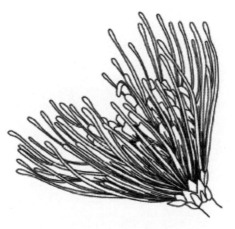

5

Add in shading lines near the base of the flower. These lines will not extend all the way up across the "petals," but will instead draw the focus and attention back toward the flower's base.

6

Go over your illustration in ink to finalize your details and erase any pencil marks that might still be visible.

IRIS

THE FLOWER OF CREATIVITY

1

2

The iris does not have many petals, but the few petals it does have are unique and stunning. Begin your illustration with an oddly-shaped base petal.

Next, draw a second petal coming off the base petal from the previous step. This petal has more curves on its edges and is still unique in its shape. There is no true visible "center" to the iris; instead, you'll have several overlapping petals.

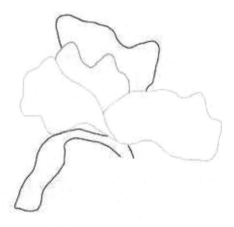

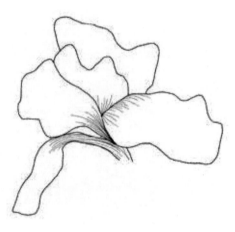

3

Add a few more petals above the two existing petals and one drooping petal below. Remember, this flower is all about unique twists and curves, so feel free to let your pencil take over as you draw.

4

Finally, add shorter shading lines only to the very center parts of the petals. While there is no real "center" of this flower, you can still use the shading lines to point toward the base of the stem.

QUEEN PROTEA

THE FLOWER OF STRENGTH

| 1 | 2 |

Start your queen protea with a long c-curve acts as the base of the flower. This curve is almost like a cup that holds the rest of the flower. Add three main petals to the top of this c-curve to create the first layer of petals. Then, add two petals in the "windows" of the previous three petals.

Add another layer of petals, allowing the petals to get a little bit bigger with each new layer. These petals may appear like pointy scales on a dragon; in reality, they are usually pink and fuzzy!

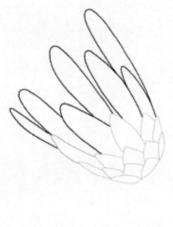

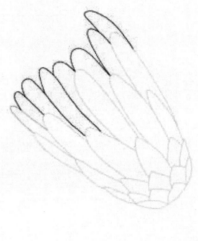

4

Add another layer of elongated petals that are rounder at the tips. Now our scales have stretched into what look like hot dog fingers.

Add one more layer of petals that seemingly evens out the flower across the top with rounded ends. It doesn't need to be straight across at the top, so no need for a ruler here.

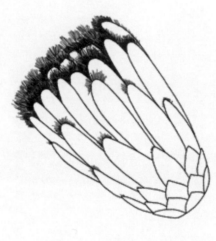

$\boxed{5}$

The shading for the queen protea is unique of all the flowers
in this book because of the flower's fuzzy petals! Rather than
draw shading lines on the petals themselves, use short lines
to create hair-like structures sprouting from the tips of the
petals. Include a few lines on the smaller petals towards the
bottom, increasing the length and density of the lines as you
get close to the top of the flower. By the end, it will appear as
though there is a "crown" around the top of this flower due to
the nature of the shading.

PRACTICE

FLORAL ARRANGEMENT

Drawing a full floral arrangement can be intimidating and overwhelming, especially on a first attempt. An arrangement can appear complex at first glance, with a multitude of flowers, leaves, and greenery in all different directions. Breaking an arrangement into small steps makes such an illustration entirely achievable!

That said, the floral arrangement project is the most difficult, which is why I saved it for last. However, taking the time and effort to learn how to draw an arrangement is well worth it! Just take things one flower at a time.

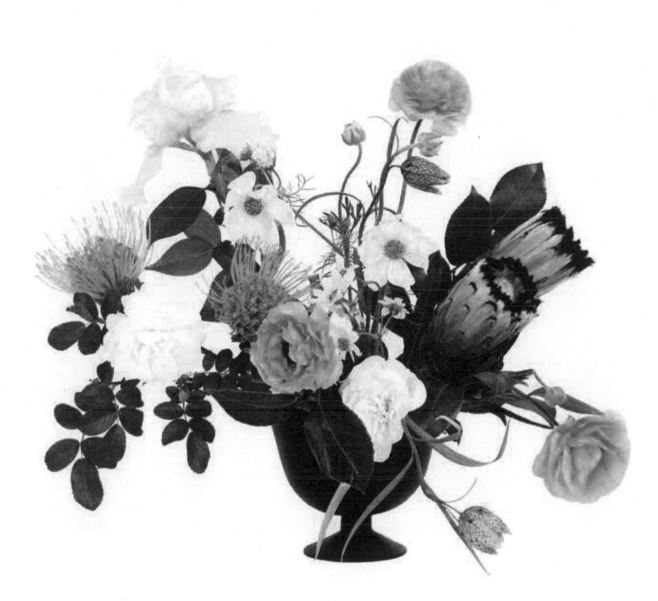

For this project we will be using this photo of a flower arrangement. You may choose use to real floral arrangements for inspiration as you draw.

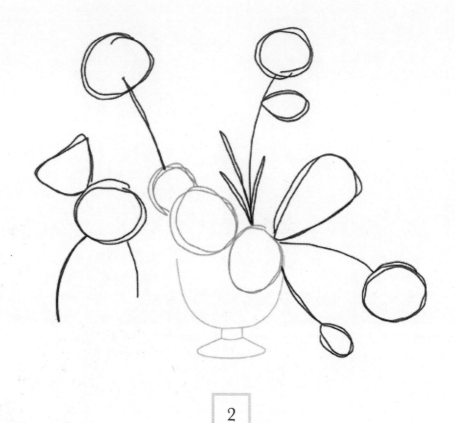

1	2

Start your floral illustration by drawing a vase. The vase will act as an anchor for your arrangement, as all of the flowers will stem from the vase. It's best to use a pencil as you begin to draw; there are a lot of elements to come, and you'll want to erase some lines later on.

In pencil, add guidelines for the main shapes and stems of your floral arrangement. Start with the placement of the main flowers closest to the vase and then work your way out. These guidelines will help with your placement and proportions of flowers and will be erased later.

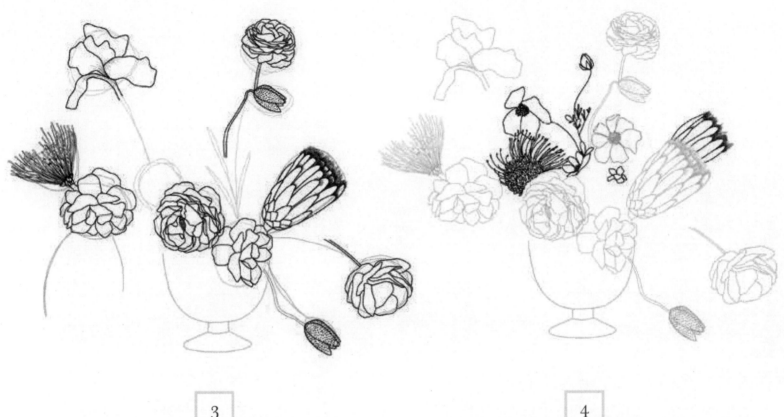

<table>
<tr><td>3</td><td>4</td></tr>
</table>

3

Add in the first "layer" of flowers by placing your main flowers in the larger placeholders. Be sure to refer back to your real arrangement to get a better idea of angles and directions the flowers should be pointing.

4

Add in a second layer of smaller flowers. The flowers in this layer will be a bit smaller, and many of the flowers will be side views or partially hidden behind the larger flowers.

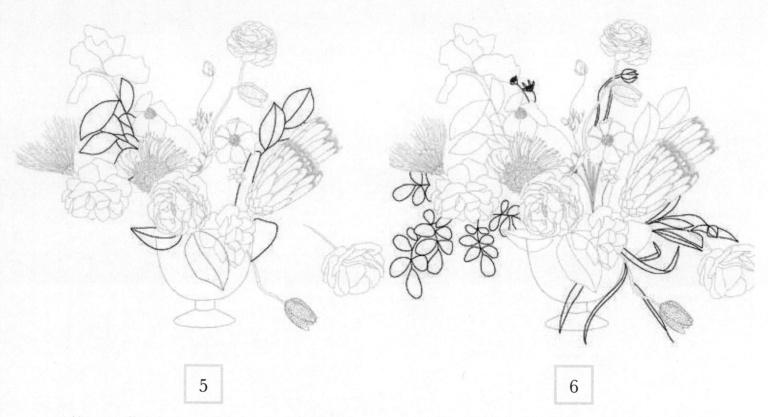

| 5 | 6 |

Add a series of large leaves near the vase, close to the base of your main flowers.

Add in another layer of smaller leaves and start to connect items in the arrangement together with stems.

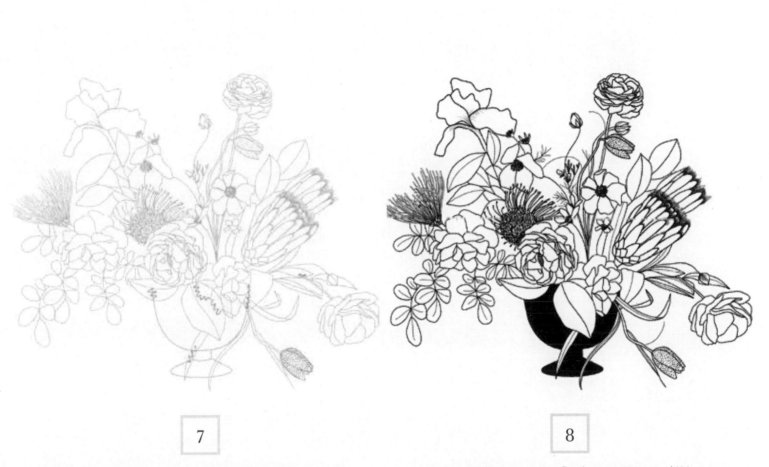

| 7 | | 8 |

Erase any overlapping detail lines, particularly those near the vase. Also be sure to erase any lines that are "behind" your leaves and petals.

Last but not least: trace your floral arrangement in ink! You can also fill in the vase to it is a solid color; doing so will add contrast to your illustration.

PRACTICE

FLORAL ARRANGEMENT

FLORALS BY HAND

GOLDEN ASTER

DIGITIZE

Congratulations! You've made it to the last project in this book! This is truly something to celebrate because it means that you have dedicated quality time to learning something new.

Whether you picked up this book for personal enjoyment or to learn a new skill to use professionally, now is a great time to share what you have learned with others! Don't be afraid to share; rather, be proud of your dreams and your accomplishments and celebrate them!

I believe it is important to celebrate even the little things; it's not only big and loud things that deserve recognition. In fact, it is often the little victories and accomplishments that lead you to bigger and better things. It is my hope that you will be able to use the lessons you have learned from this book to find your own unique style and share it with the world.

GOLDEN ASTER

THE FLOWER OF PATIENCE

Start this flower by drawing a rough, organic circle as the center of your flower in pencil. This is simply a guideline and will be erased later. We will also be scanning this illustration later, so make sure you are using marker bond paper.

Next, fill in the center circle with smaller circles. Use a variety of shapes and sizes as you fill in the center.

3

Draw five thin petals evenly spread out around the center of the flower.

4

Add six more thin petals in the empty spaces or "windows" of the anchor petals drawn in the previous step.

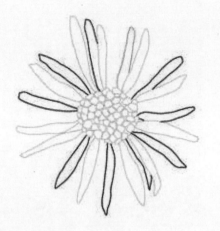

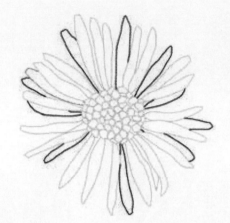

<div style="text-align:center">

5

</div>

Add about ten thin petals as you continue to fill in the white space between petals. Start with a petal toward the top of the flower and work your way around clockwise.

<div style="text-align:center">

6

</div>

Add another round of thin petals to the remaining white space. Many of the petals in this step will be overlapping or hidden behind other petals.

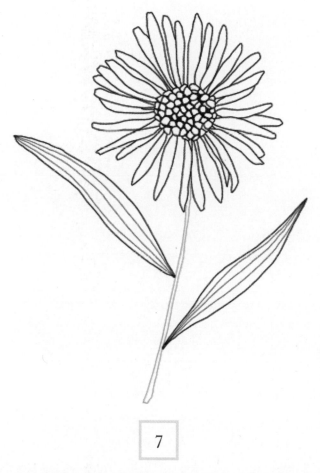

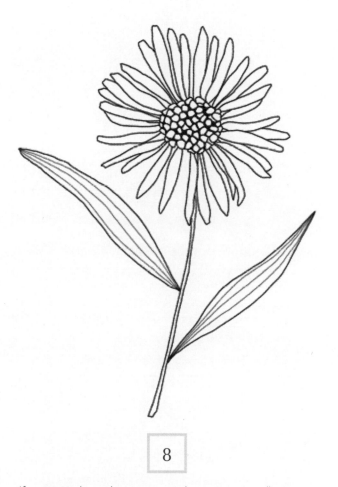

| 7 | 8 |

Keep this flower simple; all that's left to do is add a stem and a few leaves.

If you started your drawing in pencil, now trace your illustration in ink. Then, make sure all of your pencil marks are completely erased.

PRACTICE

GOLDEN ASTER

FLORALS BY HAND

HOW TO DIGITIZE

There are many ways to digitize an illustration. I will share how I go about digitizing my work. I'll provide as many tips and tricks as I can, but bear in mind that the process of digitizing can be as simple or complex as you want it to be. My intent here is to provide a good balance that anyone can follow along with.

It is important to use marker bond paper when illustrating, as it is the best paper for scanning and digitizing. Be sure to draw your flower large enough so that all of the details are visible. Illustrations smaller than a half page are too small for scanning. You need good, crisp lines to ensure that all of your details are clear; delicate lines are more difficult to capture in a scan. Use black ink, as it is the most visible in a digital scan. (You can change the color later using your computer or device.) Last, allow all of the ink to completely dry and erase any pencil marks that you don't want to show up in your final product.

Beginning on the next page, you will find step-by-step directions for digitizing your illustration using a scanner and Adobe® Illustrator®. Don't have a scanner? You can actually take a photo of your illustration! Just be sure to have a lot of natural light and photograph your illustration looking directly onto the drawing from above.

Once you feel like your illustration is ready to go, scan your image. Scan your illustration at a 600 DPI (DPI stands for Dots Per Inch). The larger the DPI, the larger the file the scanner creates, thus capturing more details. Follow the instructions on your scanner and save your image to your desktop.

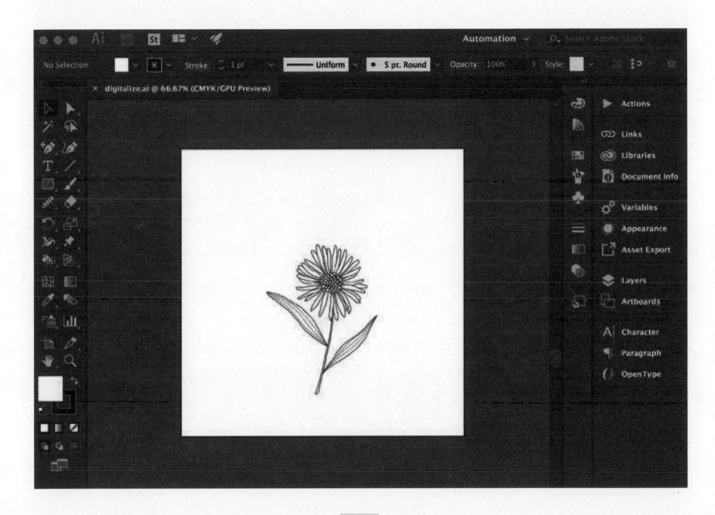

2

Using Adobe Illustrator, open a new artboard. You can either click and drag your image into Illustrator or place your image file. To place your image, select *File* from the menu bar at the top of the screen, then click *Place* and select the image you want to use.

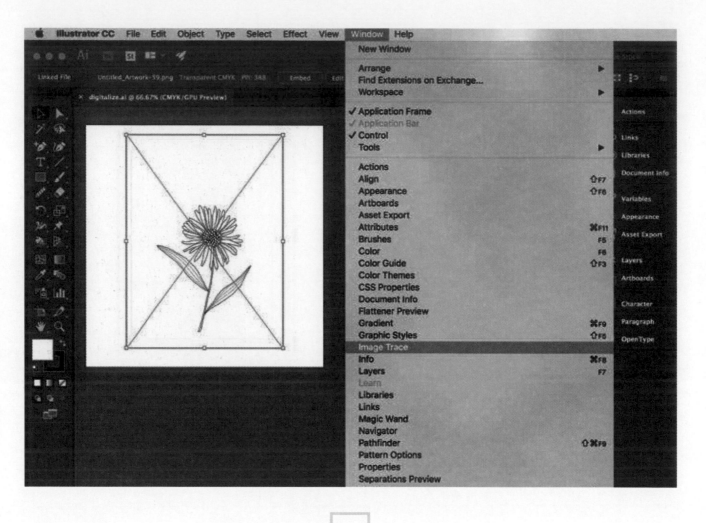

3

Click your illustration and make sure it is selected. When an image is selected, there will be a blue frame around that image. Next, select *Window* from the menu bar at the top of the screen, and then click *Image Trace*. This will vectorize your image so you will be able to change its size, color, and more. This also allows you to make the image as big or as small as you want without changing the pixels.

<div align="center">4</div>

In the *Image Trace* window, you can use the toggles to adjust the levels to get the scanned image as close as possible to your original artwork. Typically, I move *Corners* and *Noise* all the way down, move *Paths* up, and adjust the *Threshold* just a bit. I also recommend that you click *Ignore White* near the bottom of the window. Doing so leaves only the lines visible, and makes the background transparent. Once your illustration looks the way you want it to look, click *Trace* in the bottom right-hand corner of the window.

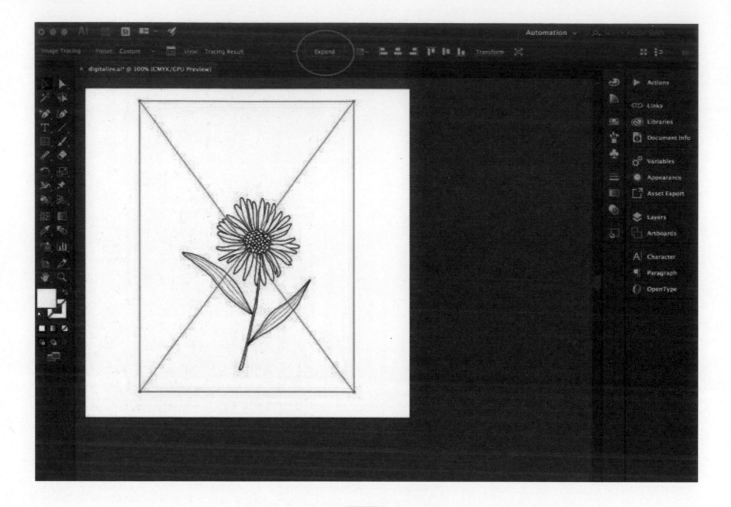

Again, make sure the image is selected and that the blue frame is visible around your illustration. The next step is to click *Expand*, located at the top in the middle of the tool bar. This will allow you to edit the lines of your illustration.

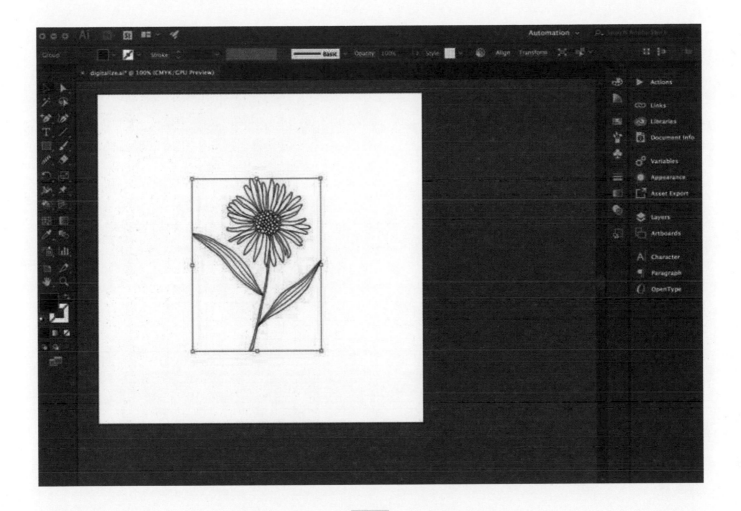

6

Once your scanned illustration has been "expanded," you will
see the outline of your drawing will turn blue. This means you
have created paths or vectors for your image, making it editable.

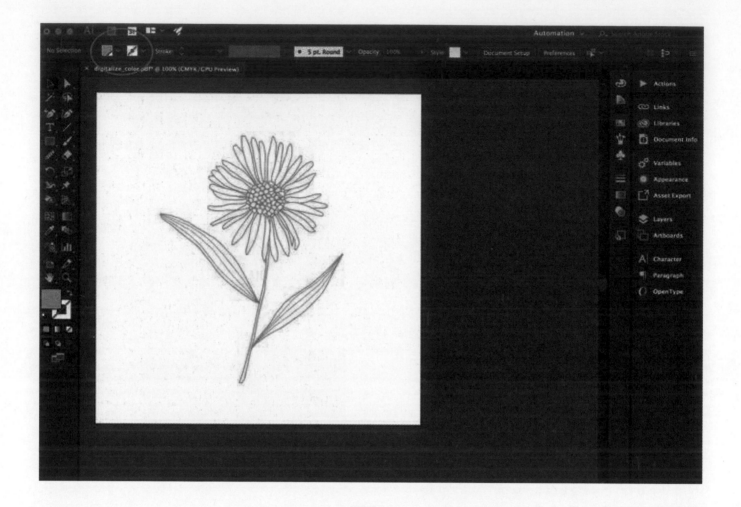

7

Now you are able to change certain illustration details, such as the color. To change the color, click on your image and then click the down arrow on the color selection box in the upper left-hand corner. The box on the left is "fill color" and the box on the right is the "outline color." Typically, I leave the outline feature alone.

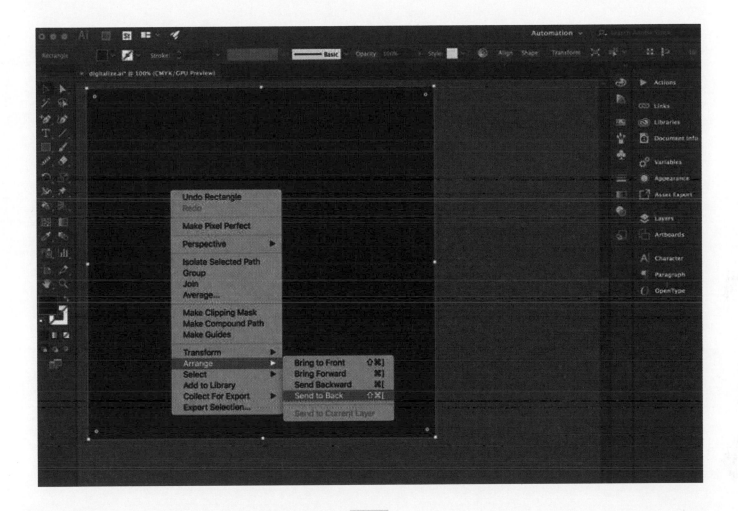

8

If you want a different background color, create a square that is the same size as your artboard. Right click the colorful square and select *Arrange*. Next, click *Send to Back* to make it the background for your illustration.

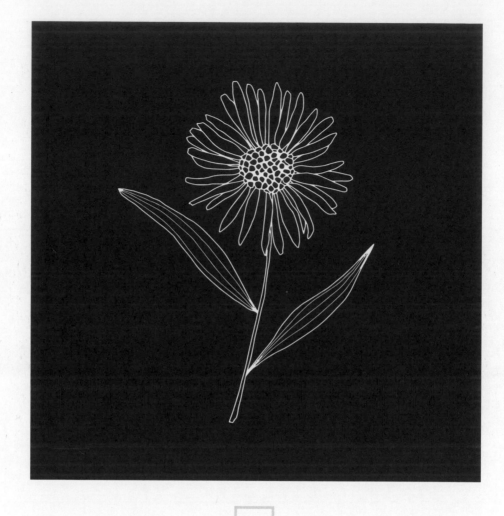

<div align="center">

9

</div>

Now that you have a black background, repeat the steps to change your illustration color to white. This will make it pop! Last, save your file. You did it!

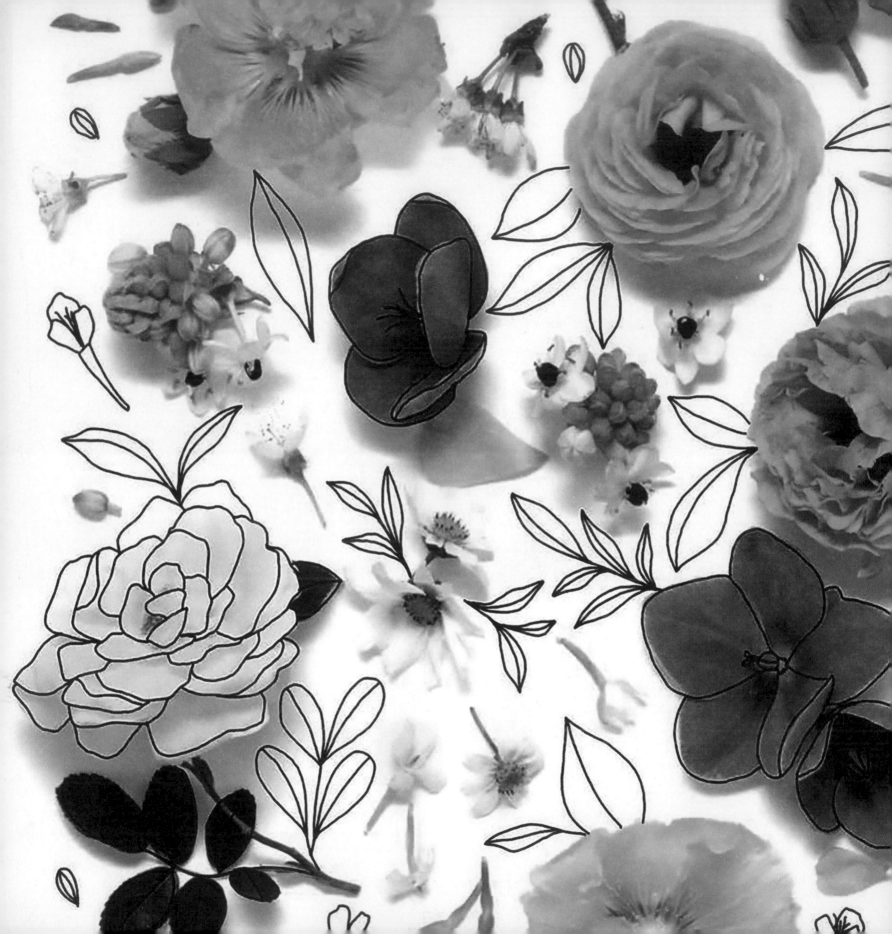